Collins gem

Seashore

Rod and Ken Preston-Mafham

HarperCollins*Publishers*
Westerhill Road, Bishopbriggs, Glasgow G64 2QT

www.collins.co.uk

First published 1999
This edition published 2004

Reprint 10 9 8 7 6 5 4 3 2 1

© Rod and Ken Preston-Mafham (text) 1999
© Permaphotos Wildlife (photographs) 1999

ISBN 0-00-717859-X

Printed in Italy by Amadeus S.p.A.

The copyright in the photographs belongs to the
Authors/Permaphotos Wildlife, and to the following:
Aquila/Permaphotos Wildlife: D. Owen, 240; N. Ede, 241;
A. Cardwell, 242; A. J. Bond, 248; S. Rowlands, 251 Permaphotos
Wildlife: A. Hubbard, 236; M. Preston-Mafham, 238; R. Brown, 252

The copyright in the illustrations belongs to HarperCollins,
and to the following: Brin Edwards (pp.4-5), Marjorie Blamey
(flowers), Ann Farrer (grasses)

What is it that, like a magnet, draws millions of us each year to our coastline? For most of us it is a chance to get away to somewhere different to relax and enjoy sun, sea and sand. For others it is a chance to appreciate the great beauty of much of our coast and perhaps to look in more depth at what wildlife it has to offer. While there are those of us who are keen birdwatchers, others who know their seaweeds and some who are experts on marine animals, most of us have a limited knowledge of what we might find along the coastline. This is where this little book comes in. Its aim is to give a general insight into the most common animals and plants that you might find, together with the occasional rarity for you to keep a special look out for.

The book is suitable for everyone who enjoys spending time walking, playing or relaxing along the coasts of Britain, Ireland and northern France and would like to know what they might find along the way. Emphasis has been placed on the most accessible parts of the coast, such as sand, shingle, rocks, cliffs and dunes, while the myriad creatures that live in the glutinous mud of our estuaries and saltmarshes, hardly a place for an afternoon ramble, have been largely ignored. If this book whets your appetite then there are many excellent field guides available which will give you a deeper insight into the wonders of our coastal wildlife.

Parts of the Seashore

Each plant and animal species described
in this book belongs to a particular part
of the seashore. This diagram illustrates
the different zones of rocky and sandy
shores mentioned in the species entries.

Strandline

UPPER SHORE

MIDDLE SHORE

LOWER SHORE

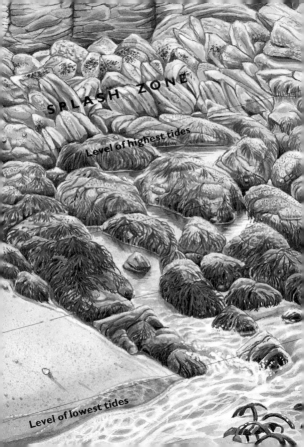

SPLASH ZONE

Level of highest tides

Level of lowest tides

6 Contents

SAFETY ON A COASTAL WALK

There are a number of points to remember when you are on a visit to the coast.

1. It is important to be aware of the state of the tide, and whether it is ebbing or flowing when you are on the shore. A set of tide-tables is very useful and costs little.
2. Estuary mud can be very sticky and it is best not to wander on to it; you may get trapped.
3. Many of our cliffs are made of crumbly rock, so do not go too close to the edge.
4. Always wear something on your feet when searching a rocky shore for sea creatures; barnacles especially have razor-sharp shells which easily cut the skin.

Rocky Coast

With dozens of species of seaweeds and literally hundreds of different species of animals, including anemones, worms, molluscs, crustaceans, starfish, sea squirts and fish, beaches are a marvellous place to explore during a ramble along the coast. Not all beaches will turn up the same animals or plants, for the degree of exposure to the waves has a definite effect upon the distribution of many organisms and very exposed areas of rock may be almost totally devoid of life. Also, soft rocks such as chalk and shale are too easily eroded by the sea and therefore support little life.

Once you are on the shore, the seaweeds are very obvious but many of the animals will have to be sought out under stones, amongst weed and in rock pools. There is, however, one most important rule to be followed when looking for crabs and other sea animals. It is that when you turn a stone over always turn it back again! Also, when turning it back over be careful to make sure that you do not squash any of the small creatures that live under it. Placing a small stone to lower a larger one down onto, to create a gap beneath it, will often prevent small creatures from being squashed, without having any detrimental effect upon their environment beneath the stone. The animals which live in sand are more difficult to find, though a little digging with even a child's spade may turn up the odd cockle or sand worm.

Gutweed

Enteromorpha intestinalis

The fronds of gutweed are actually tubes with constrictions at irregular intervals giving the appearance of a string of pale to dark green bladders. They are attached at the base to rocks or stones and, with their ability to stand quite high sea water dilution, may often be found in quantity where freshwater streams flow across the beach.

TYPE Green.
LENGTH To 75 cm.
HABITAT Upper shore.
RANGE All coasts.
SIMILAR SPECIES *E. linza* is found in similar situations but is more delicate, *E. compressa* has branching fronds.

This seaweed is well named for its fronds do indeed resemble the leaves of a rather limp lettuce. The fronds, which are pale green, become white-edged once they have released their reproductive cells. Like the previous species, sea lettuce can tolerate quite high dilutions of the pools in which it lives. Care should be taken when stepping on it as it is very slippery.

TYPE Green.
SIZE Frond 10–30 cm across.
HABITAT All levels on the shore.
RANGE All coasts.
SIMILAR SPECIES *Monostroma grevillei* from the lower shore has thinner, funnel-shaped fronds.

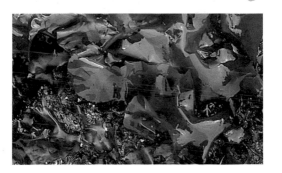

Called sea beads because the plant consists of long, fine threads which, under a magnifying glass, look like strings of beads. It grows as single threads or clumps attached to rocks in pools containing sand or you may find clumps of it floating around free in such pools. It is quite abundant in summer and can stand considerable dilution of the pool by rainwater.

TYPE Green.
LENGTH To 30 cm.
HABITAT Middle to the upper shore.
RANGE All coasts.
SIMILAR SPECIES *Cladophora rupestris* is coarser, darker and found from the middle shore down.

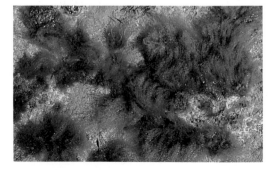

Velvet horn has a preference for growing on rocks which are embedded in sand or mud. Its growth form is very much like that of a deer's antlers, the stems branching dichotomously (in twos), and the whole plant has a velvety feel to it, hence its common name.

TYPE Green.
LENGTH To 30 cm.
HABITAT Lower shore down on rocks.
RANGE Mainly south-western coasts.

Jelly Buttons

Leathesia difformis

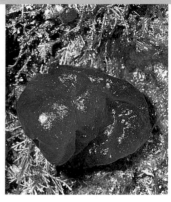

At first sight this plant hardly resembles a living organism, let alone a seaweed, looking as it does like an irregular blob of brown jelly. The surface is slippery and young plants are solid, becoming hollow but thick-walled as they age. It grows on the surface rocks and stones and also 'hitches a ride' by growing on other small seaweed plants.

TYPE Brown.
SIZE 20–50 mm across.
HABITAT Middle and lower shore.
RANGE All coasts.
SIMILAR SPECIES Oyster thief, *Colpomenia peregrina* is not gelatinous and is covered in brown dots.

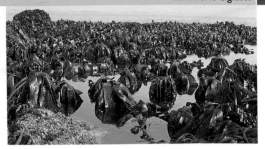

This is one of a group of large seaweeds collectively referred to as 'kelps'. The plant grows attached to rocks by a branched, root-like structure, the 'holdfast', from which arises a smooth, oval stem. At the end of this is the main blade of the plant, which is broad and subdivided into a number of strap-like 'fingers'. It is only fully exposed at very low tides.

TYPE Brown.
LENGTH 2 m or longer.
HABITAT Lower shore; and below, permanently submerged.
RANGE All coasts.
SIMILAR SPECIES Cuvie, *Laminaria hyperborea* has a rough stem and grows to 3.5 m.

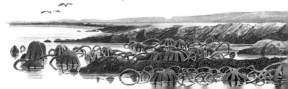

Laminaria saccharina

Another of the kelps, this species has a long, unbranched frond with wavy edges arising from a short stem attached to a branching holdfast. Like most kelps, it is most likely to be seen only on the lowest tides but it may also be seen to good purpose in very deep, permanent rock pools. The dried fronds are used to forecast rain, since they take in water and become limp as air humidity increases.

TYPE Brown.
LENGTH Up to 4 m.
HABITAT The lower shore and permanently submerged.
RANGE All coasts.

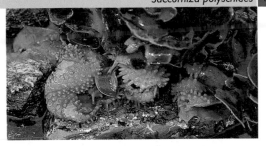

Probably our largest seaweed it is best recognised by its holdfast and stem (illustrated), which resemble those of no other species. The golden brown frond is broad, flat and usually fingered, like that of oarweed, though in quieter, protected situations it tends to be less divided. This seaweed and its characteristic holdfast is often washed up following summer storms.

TYPE Brown.
LENGTH Up to 4.5 m.
HABITAT The very bottom of the shore and below.
RANGE All coasts.
SIMILAR SPECIES The fronds resemble those of oarweed.

Thongweed is a rather confusing seaweed. The main plant is like a small, brown toadstool with a cupped top up to 3 cm across, attached to rocks on the lower shore. Long, slim, branching reproductive bodies grow out of the centre of the main plant during spring and summer, leaving just a short stump when they have matured and eventually broken off.

TYPE Brown.
LENGTH Reproductive filaments to 2 m long.
HABITAT Lower shore.
RANGE All coasts.
SIMILAR SPECIES Mermaid's tresses, *Chorda filum* is unbranched and does not grow from a 'toadstool'.

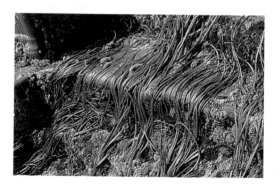

Japweed

This seaweed is a very unwelcome addition to our marine flora, having been accidentally introduced on imported oyster stocks from its natural home in the Pacific Ocean. It grows very vigorously and is ousting native species, especially in shallow, sheltered waters. With its alternately branching stem and fronds looking like small leaves, it has the appearance of a land plant which has been washed into the sea.

TYPE Brown.
LENGTH 1 m or more.
HABITAT Sea shore and estuaries.
RANGE SW Britain and spreading.

Knotted Wrack

Ascophyllum nodosum

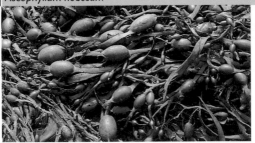

The irregular, branching fronds of this seaweed have egg-shaped bladders containing gas spaced out along them. The gas bladders allow the plant to stand upright in the water when the tide is in so that they can obtain the maximum amount of light. During the summer short-stalked fruiting bodies, resembling shrivelled grapes, are produced along the fronds.

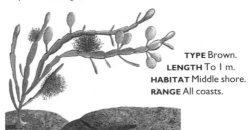

TYPE Brown.
LENGTH To 1 m.
HABITAT Middle shore.
RANGE All coasts.

Growing as it does at the top of the shore this seaweed is most likely to be found in a completely dried out, crisp state and indeed, during neap tides it may stay uncovered for a number of days. It is pale brown to orange when wet but appears almost black when dry. Fruiting bodies are produced at the ends of the fronds.

TYPE Brown.
LENGTH To 15 cm.
HABITAT The very top of the shore.
RANGE All coasts.

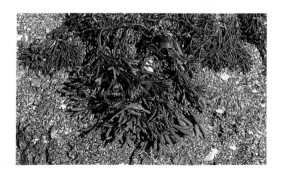

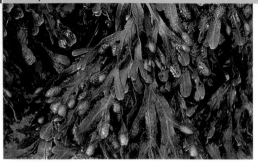

Spiral wrack is found growing on rocks high on the shore in a band immediately below channelled wrack. It is less able to stand drying out than the latter and is always wetted by the high tides each day. The fronds may or may not be twisted, so they can be spiralled or flat, and they lack air bladders. Again, fruiting bodies form at the tips of the fronds during the summer.

TYPE Brown.
LENGTH To 20 cm.
HABITAT Upper shore.
RANGE All coasts.
SIMILAR SPECIES Other wracks.

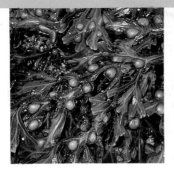

As its name implies, this seaweed has pairs of
almost spherical gas bladders at intervals along the
branching fronds, permitting the plants to float
upright when the tide is in. It has an alternative
common name of popweed, since when squeezed
the bladders explode with a loud pop. This
makes them a great favourite with children
but does not do the plant a lot of good.

TYPE Brown.
LENGTH To 1 m.
HABITAT Middle shore, quite tolerant of
estuarine conditions.
RANGE All coasts.
SIMILAR SPECIES Other wracks.

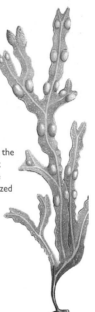

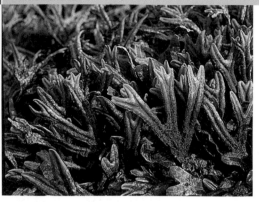

Horned wrack is intolerant of the high salt content of pure seawater and accordingly it is found growing in the brackish water of estuaries or where smaller rivers enter the sea. It is commonly found in these situations growing attached to rocks and stones. The branching fronds lack bladders and the fruiting bodies form at the tips during the summer.

TYPE Brown.
LENGTH To 90 cm.
HABITAT Estuaries and river mouths.
RANGE All coasts.
SIMILAR SPECIES Other wracks.

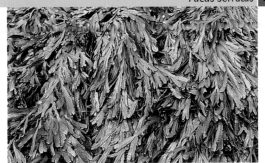

Sometimes called saw wrack, this species grows at the bottom of the shore, where it only has to withstand a short exposure to the air each day. It is easily recognised for the edges of the thin, flat fronds bear saw-like teeth and there are no gas bladders. The tips of the fronds swell slightly and change to a more orange colour as the fruiting bodies develop.

TYPE Brown.
LENGTH To 60 cm.
HABITAT Lower shore.
RANGE All coasts.

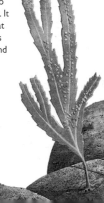

Cystoseira tamariscifolia

Well-named because the fronds very much resemble the leafy branches of the tamarisk, an introduced shrub which itself grows along many of our coastlines. The highly branching fronds are dark brown when out of the water but when the sun shines on them when they are in a pool they have an unmistakable blue iridescent sheen.

TYPE Brown.
LENGTH To 45 cm.
HABITAT Lower shore pools.
RANGE SW coasts.

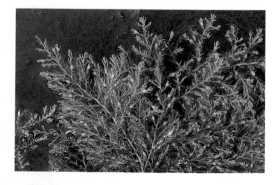

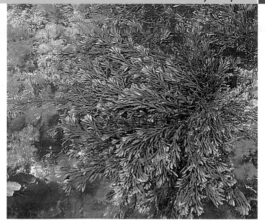

Sea oak has a rather flattened frond, a sort of gingery brown in colour, which branches alternately, each branch itself being further branched. The branchlets are often developed into pointed, oval air bladders, which resemble the seed pods of some higher plants, since they are clearly divided into separate chambers.

TYPE Brown.
LENGTH To 1 m.
HABITAT Lower shore, mainly in pools.
RANGE Most common around SW coasts.

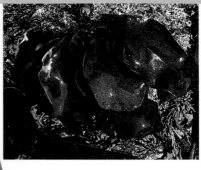

The fronds of red rags are roughly oval in shape, deep red and very thick and tough. As they age, the ends of the fronds often become split as a result of wave action, so that they literally look like a bundle of red rags hanging from a rock. Unlike the similar-looking dulse, red rags is not an edible seaweed.

TYPE Red.
LENGTH To 20 cm.
HABITAT Lower shore.
RANGE All coasts.
SIMILAR SPECIES Dulse.

A very unusual but easily recognisable seaweed as its fronds and branches are made up of a series of short, stiff, calcareous segments forming a sort of chain. It is normally purple-pink in colour but in brighter light can be much paler and some fronds can be green. When it dies, it leaves a coral-like white skeleton behind, still attached to the rock on which it grew.

TYPE Red.
LENGTH To 12 cm.
HABITAT Middle shore pools.
RANGE All coasts.
SIMILAR SPECIES *Jania rubens* is much smaller and grows in tufts on other seaweeds.

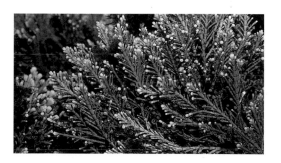

Red Encrusting Algae

Lithophyllum and Lithothamnion spp.

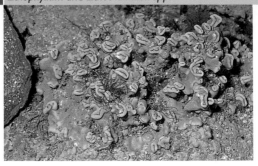

Frequently on a rocky shore you will discover areas of rock, often of
some considerable size, covered in what appears to be a thick layer of
very pale pink to deep pink or red paint. It may be smooth or, in some
instances, puckered. These are, in fact, encrustations of species of red
seaweed which have a calcareous skeleton.

TYPE Red.
HABITAT Middle shore down, on rocks.
RANGE All coasts.
SIMILAR SPECIES Other red encrusting algae.

Dulse forms unequal branching fronds, dark reddish-purple in colour, sometimes with smaller branches resembling leaves forming along the edges of the fronds as they age. It will also grow on larger seaweeds, such as oarweed, as well as on rocks. Dulse is an edible species, which may either be cooked or eaten raw.

TYPE Red.
LENGTH To 30 cm.
HABITAT Lower shore, on rocks.
RANGE All coasts.
SIMILAR SPECIES Red rags, which is, however, much thicker and redder.

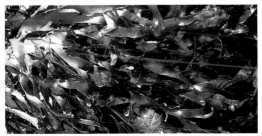

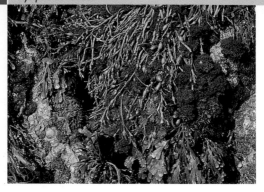

Egg wrack, the brown seaweed, often has the appearance of being covered in dark red 'flowers', which are in fact clumps of red epiphyte. This small, feathery, red seaweed establishes itself on the wrack at sites where the latter's fruiting bodies have broken away from the fronds. The red weed uses the wrack to obtain a 'lift' up towards the sunlight while they are submerged.

TYPE Red.
LENGTH 30–40 mm
HABITAT On fronds of egg wrack.
RANGE All coasts.
SIMILAR SPECIES *Jania rubens* has hard, calcareous fronds but also grows on seaweeds.

Laver is a very thin, membranous species which gives no indication at all that it is one of the red seaweeds when the tide is out, for it can vary in colour between greenish when young to purplish when mature and black and brittle when dried out on a hot day. This is the basis of the famous 'laver bread', a boiled form of the weed eaten in South Wales.

TYPE Red.
LENGTH To 30 cm.
HABITAT Most levels of the shore.
RANGE All coasts.
SIMILAR SPECIES Other
Porphyra spp.

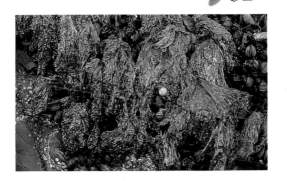

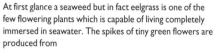

At first glance a seaweed but in fact eelgrass is one of the few flowering plants which is capable of living completely immersed in seawater. The spikes of tiny green flowers are produced from
mid-summer into the autumn. One of the more interesting denizens of the eelgrass 'forests' is
the pipefish (p.107).

COLOUR Green.
LENGTH To 30 cm.
HABITAT Estuaries.
RANGE Distribution patchy but common where it is found.
SIMILAR SPECIES Other *Zostera* spp.

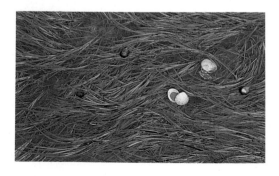

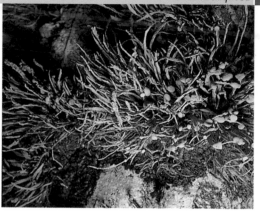

The only common tufted lichen found along the coast in close proximity to the sea. It has stiff, almost brittle 'stems', which branch somewhat, forming tufts. In places the tufts can become so dense as to form a kind of sward, almost like a lawn.

COLOUR Grey-green.
HABITAT On rocks in the splash zone above high tide.
RANGE All coasts.

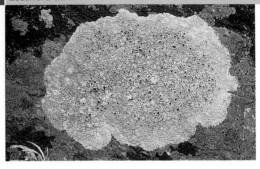

This is a granular, encrusting lichen which can form irregular patches in excess of 500 mm across, though younger individuals are smaller with a more regular outline. At certain times of the year the reproductive bodies, the gemmae, are formed and these resemble small black cups with a white rim.

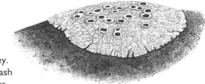

COLOUR Grey.
HABITAT Splash zone, on rocks.
RANGE All coasts.
SIMILAR SPECIES Other *Lecanora* spp.

This lichen is so widespread and common that it often paints a yellow band along the rocks in the splash zone above high tide level. It is a coarse, somewhat 'leafy', encrusting lichen forming patches up to 100 mm across, though individuals may coalesce to form larger areas.

COLOUR Yellow to orange.
HABITAT Splash zone, on rocks.
RANGE All coasts.
SIMILAR SPECIES Some *Caloplaca* spp. are not leafy and are dark orange.

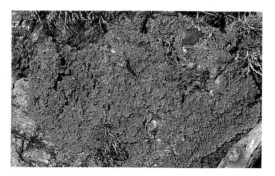

Breadcrumb Sponge

Halichondria panicea

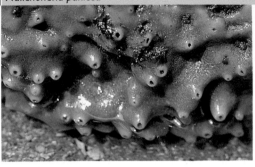

This is an encrusting sponge and bears no resemblance whatsoever to the sponges that we use in our bathrooms. This species forms a thin layer over the surface of rocks, usually in sheltered positions under overhangs or beneath dense growths of seaweed. Tiny, volcano-like structures called oscula grow up at intervals from the surface of the sponge, which can form patches up to 200 cm² in area.

COLOUR Green, pale yellow or orange.
HABITAT Lower shore, on rocks.
RANGE All coasts.
SIMILAR SPECIES Other encrusting sponges.

The only other common encrusting sponge found around our coastline. It often grows with the breadcrumb sponge but is fairly easy to distinguish from it. The surface of the sponge is rough and puckered up, giving a striped appearance and the oscula are smaller and arranged in a very haphazard way.

COLOUR Orange to orange-red.
HABITAT Middle to lower shore, on rocks.
RANGE All coasts.
SIMILAR SPECIES Other encrusting sponges.

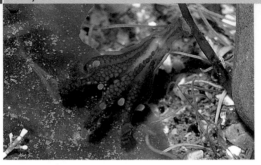

A small, trumpet-shaped creature which is, in effect, like a jellyfish lying on its back. Half of the total height is taken up by the stalk, which is attached to the weed on which it lives by means of a basal sucker. It has eight arms on the end of which are up to 100 tiny tentacles.

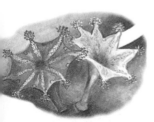

COLOUR Green or reddish.
HEIGHT To 40 mm.
HABITAT Lower shore on algae.
RANGE All coasts but less common as you go north.
SIMILAR SPECIES A number of other species varying in size, colour and arm arrangement.

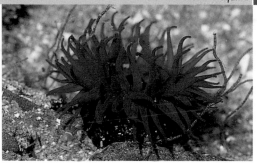

This is by far the commonest of our anemones and is likely to be found on almost any shore on which it can find a place to anchor itself and it is even quite tolerant of some dilution of the seawater. When the tide is out it is normally to be found as a blob of coloured jelly hanging from a rock but careful searching will often find one in a rockpool with its tentacles fully extended.

COLOUR Shades of red, brown and green.
HEIGHT To 50 mm.
HABITAT All but the uppermost shore, on rocks.
RANGE All coasts.
SIMILAR SPECIES Not on the exposed shore.

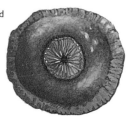

Actinia fragacea

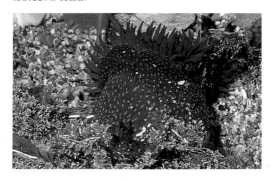

For many years this anemone was thought to be just a form of the beadlet anemone but it is now recognised as a separate species in its own right. Its common name fits it well for when it is left exposed it resembles a strawberry attached to a rock. It occurs further down the shore than the beadlet and is nothing like as common.

COLOUR Red with greenish spots.
HEIGHT To 100 mm.
HABITAT Lower shore, on rocks.
RANGE All coasts.

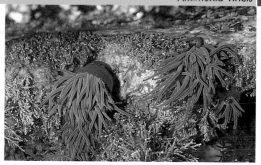

An interesting animal for its green colour is due to the presence of tiny algae living within its cells. Unlike the beadlet anemone, it cannot contract its tentacles and as a result it is more often found in pools. It reproduces by splitting down the middle and as a result rows of snakelocks anemones, all derived from a single original animal, may be found.

COLOUR Grey or green with pink ends to the tentacles
DIAMETER To 50 mm.
HABITAT Lower shore, on rocks or seaweeds.
RANGE Not on east coast or eastern part of south coast.

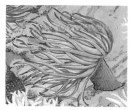

Gem Anemone

Bunodactis verrucosa

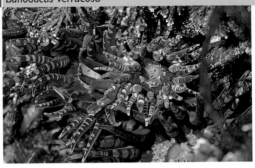

The gem anemone is somewhat more difficult to find than the previously described anemones, since it lives in crevices in rockpools into which it can withdraw when disturbed. It has fewer tentacles than the other anemones and the outer surface of the body is covered in rows of 'warts' giving it a rough texture.

COLOUR Greenish.
HEIGHT To 80 mm.
HABITAT Middle and lower shore in rock crevices.
RANGE West coast, Channel Islands to Isle of Man.
SIMILAR SPECIES A number of uncommon species.

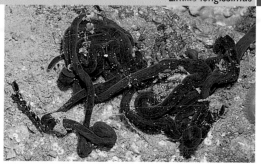

Well-named, because it does resemble a shining black bootlace, it is not possible to confuse this with any other creature on the shore. What is absolutely amazing is that an individual worm of 30 m in length has been recorded. They are usually found in a curled-up state under stones or in the crevices in rocks.

COLOUR Dark brown to almost black.
LENGTH To 10 m, sometimes more.
HABITAT Lower shore.
RANGE Not the south coast, more common in the north.
SIMILAR SPECIES Other bootlace worms are shorter and differently coloured.

Green Leaf Worm

Eulalia viridis

The only bright green worm which is at all
common around our coastline. At
times it can occur in quite large
numbers and it may be found crawling
actively over the surface of rocks
or among seaweeds when the
tide is out.

COLOUR Bright green.
LENGTH To 150 mm.
HABITAT Rocks on the shore.
RANGE All coasts.
SIMILAR SPECIES *E. bilineata* is smaller, paler and mainly on
SW coasts.

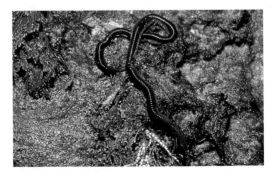

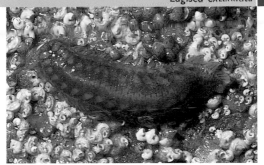

This is one of a number of similar scale worms, so-called because they have pairs of interlocking, hard scales along their backs, which can only be precisely identified with a powerful hand lens. On being discovered beneath a stone, they usually remain motionless for a short time before 'scuttling' off away from the light.

COLOUR Shades of grey-brown.
LENGTH To 40 mm.
HABITAT Under rocks and stones.
RANGE All coasts.
SIMILAR SPECIES Other scale worms.

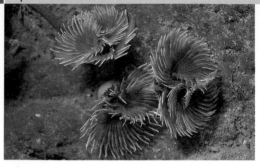

This is one example of a number of tube-dwelling worms which when feeding extrude rings or fans of tentacles from their head ends. They are most likely to be found in rockpools when, despite the tide being out, a number of them may continue to feed. They include some of our most attractive worms.

COLOUR Greenish or brownish with pale tentacles.

LENGTH To 100 mm.

HABITAT Rock crevices.

RANGE Mainly western and southern coasts.

SIMILAR SPECIES There are many similar tube-dwelling worms on the shore.

At first glance the tubes of this worm look more like some
geological feature or a fossil than the product of a living organism.
The tubes often cover the undersides of large stones and rocks and
if one of these is placed in a rockpool the worms will often
protrude their head ends, which bear a ring of tentacles, and begin
to feed.

COLOUR Reddish brown with
red and white tentacles.
LENGTH To 25 mm.
HABITAT On stones and
shells on the lower shore.
RANGE All coasts.
SIMILAR SPECIES Other
calcareous tube worms.

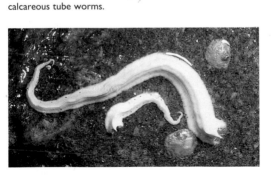

Calcareous Tube Worm

Spirorbis spirorbis

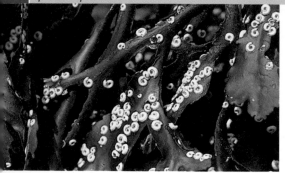

At first glance the tubes of this tiny worm appear to be the shells of a small, very flattened marine snail. Unlike the latter, however, they cannot move for the tubes are affixed permanently to the substrates on which they are found. As with other tubeworms, they stick the head end out to feed when the tide comes in.

DIAMETER 2–3 mm across the coiled tube.
HABITAT On brown algae.
RANGE All coasts.
SIMILAR SPECIES Other *Spirorbis* spp.

This is the commonest of the upper shore
encrusting barnacles and can occur in
countless millions on the rocks on
which it lives. A number of plates
form a cone, at the centre of which
are two pairs of symmetrical plates,
which open up allowing the animal to
stick out its legs to feed.

COLOUR Plates greyish white.
DIAMETER To 10 mm.
HABITAT On rocks, middle shore upwards.
RANGE All coasts, becoming less common in the north.
SIMILAR SPECIES Other acorn barnacles.

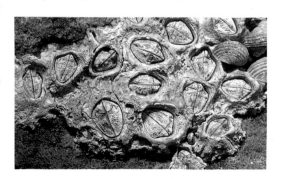

Semibalanus balanoides

At first glance indistinguishable from the previous species, the acorn barnacle lives further down the shore, though they do overlap. With good eyesight, or a small hand lens, it is fairly easy to separate the two. Whereas in the star barnacle the four central plates are of almost equal size in the acorn barnacle one pair is considerably bigger than the other.

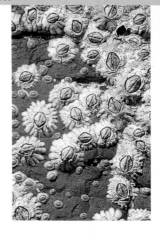

COLOUR Plates yellowish white.
DIAMETER To 10 mm.
HABITAT On rocks, middle shore downwards.
RANGE All coasts, except extreme south-west, more common in north.
SIMILAR SPECIES Other acorn barnacles.

Dark Acorn Barnacle

Balanus perforatus

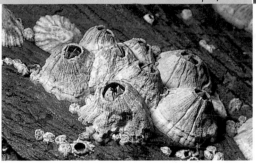

This is one of our largest encrusting barnacles, best recognised by its purplish tinge. It is much more upright than the previous two species and tends to occur in small groups in more sheltered spots. Like all encrusting barnacles, they can produce quite nasty cuts on the hands and feet when one is clambering over the rocks on which they live.

COLOUR Dark grey with a purplish tinge.
DIAMETER 1 to 30 mm.
HABITAT On rocks, middle shore downwards.
RANGE South-west Wales to Isle of Wight.
SIMILAR SPECIES Other acorn barnacles.

Pill Isopod

Sphaeroma serratum

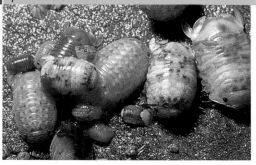

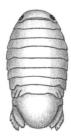

Referred to as a pill isopod because, like some species of woodlice, which it superficially resembles, this little crustacean is able to roll itself up into a perfect ball when disturbed, to look rather like a small pill. It often occurs in quite big groups containing both males and females, the latter being the smaller of the two.

COLOUR Greyish.
LENGTH To 11 mm.
HABITAT Under stones and in rock crevices, lower shore.
RANGE South and west coasts.
SIMILAR SPECIES Several.

Not easy to miss when it is present, the sea slater resembles a large, rather flattened woodlouse, of which it is a cousin. Unlike the latter, it can move very fast when disturbed. Characteristically it has a pair of long tentacles and a pair of quite large eyes on the head.

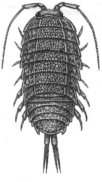

COLOUR Yellow-brown.
LENGTH To 30 mm.
HABITAT Upper shore under stones and in crevices.
RANGE All coasts.

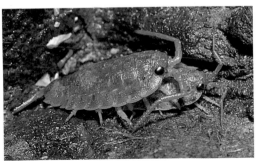

Idotea baltica

This is one of a number of similar-looking marine crustaceans, resembling woodlice, which you are likely to encounter on the shore. They are usually found among tangles of seaweed exposed by the falling tide but may occasionally be found in rockpools. A good hand lens is required to separate the various species.

COLOUR Brownish to greenish, often with white markings.
LENGTH To 30 mm.
HABITAT Lower shore.
RANGE Eastern and southern coasts.
SIMILAR SPECIES Several.

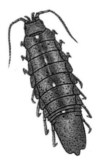

Living in pools as they do, prawns may be observed going about their daily routines even when the tide is out. Since they are semi-transparent, they are at first difficult to pick out against their background but, once identified, they can easily be followed as they search for morsels of food or indulge in what seem to be petty squabbles with one another.

COLOUR Transparent grey.
LENGTH To 110 mm.
HABITAT Rock pools.
RANGE All coasts but less common in north-east.
SIMILAR SPECIES Other *Palaemon* spp. can be as common on some shores.

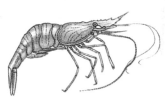

ROCKY COAST

Athanas nitescens

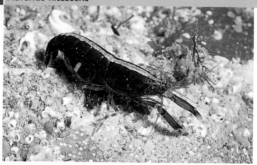

This prawn is not usually active when the tide is out and has to be sought under stones. Like other prawns it can shoot backwards in the water very rapidly, by means of a quick flip of its tail, in order to avoid danger. Its most obvious distinguishing characteristic is the white line along the centre of its back.

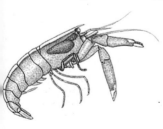

COLOUR Red, green or brown.
LENGTH To 25 mm.
HABITAT Lower shore under stones and weed.
RANGE All coasts but not common in the north-east.
SIMILAR SPECIES Other prawns.

As its name implies, this prawn is able to change its colour. During the day it may be found swimming among seaweeds on the lower shore, emerging from nooks and crannies to feed on the rising tide. Individuals then appear in the range of colours listed but at night they all become transparent blue.

COLOUR Red, green or brown.
LENGTH To 32 mm.
HABITAT Lower shore among weed on rocks adjacent to sand.
RANGE South-west coasts.
SIMILAR SPECIES Other prawns.

Pagurus bernhardus

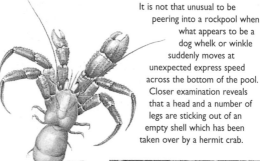

It is not that unusual to be peering into a rockpool when what appears to be a dog whelk or winkle suddenly moves at unexpected express speed across the bottom of the pool. Closer examination reveals that a head and a number of legs are sticking out of an empty shell which has been taken over by a hermit crab.

COLOUR Reddish.
CARAPACE
LENGTH To 35 mm.
HABITAT
Rockpools.
RANGE All coasts.
SIMILAR SPECIES
Other hermit crabs.

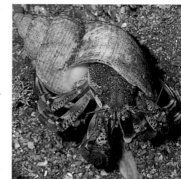

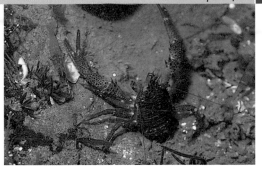

Real lobsters normally live below the lowest tide levels and are therefore seldom seen on the shore whereas the squat lobster can often be found in large numbers. Squat lobsters have long front legs with relatively weak pairs of pincers and the abdomen, instead of sticking out behind, as it does in a lobster, is tucked tightly under the thorax, as in a crab.

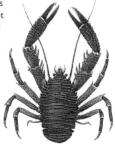

COLOUR Brown.
CARAPACE LENGTH To 35 mm.
HABITAT Under rocks and stones on the lower shore.
RANGE All coasts.
SIMILAR SPECIES Other squat lobsters.

Hairy Porcelain Crab

Porcellana platycheles

The hairy porcelain crab may at first not be readily apparent when you turn over the stone under which it lives on the lower shore. They are very flattened and hairy and hold themselves very tight to the surface of the rock in a highly cryptic fashion and it is only when they let go that they become readily observed.

COLOUR Brown.
CARAPACE LENGTH 15 mm.
HABITAT Lower shore under rocks and stones.
RANGE All coasts.

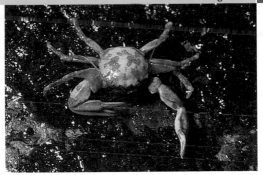

Often found in the company of the hairy porcelain crab this species is smaller and is not hairy. The claws are long and slim and the carapace, which is almost round, is smooth and sometimes quite shiny. Both this and the hairy porcelain crab feed on particles of food floating in the water when the tide is in.

COLOUR Olive green to brown, sometimes with paler markings
CARAPACE LENGTH To 10 mm.
HABITAT Lower shore under rocks and stones.
RANGE All coasts.

Hyas coarctatus

Most spider crabs scavenge and feed only upon very small items of food, thus the pincers are very small in relation to the size of the carapace, which covers the animal's body. At the same time the legs are very long in relation to the size of the body, hence the name spider crab.

COLOUR Dark reddish-brown.
CARAPACE LENGTH To 105 mm.
HABITAT Rockpools among seaweeds.
RANGE Common on all coasts.
SIMILAR SPECIES Other spider crabs.

Scorpion Spider Crab

Inachus dorsettensis

One of our commoner species, the scorpion spider crab is not that easy to spot since it uses pieces of seaweed or other organisms to camouflage itself. These are attached by the crab to various parts of the body to break up its outline. Whereas in this species the body is as broad as long, in the previous species the body is much longer than broad, an important distinguishing feature.

COLOUR Yellowish-brown.
CARAPACE LENGTH 30 mm.
HABITAT In rockpools, among seaweeds.
RANGE All coasts.
SIMILAR SPECIES Other spider crabs.

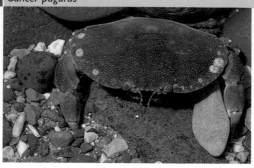

This is the largest crab that is likely to be encountered on the shore, though the very largest specimens usually occur below low water. With its pink colour and large, black-tipped pincers, it is easily distinguishable from other common crabs. Smaller specimens are common under stones while larger individuals tend to squeeze themselves into the protection of rock crevices.

COLOUR Reddish-brown.
CARAPACE WIDTH To 250 mm.
HABITAT Lower shore on rocky coasts.
RANGE All coasts.
SIMILAR SPECIES Other crabs.

This is a very attractive crab which is able to give an extremely painful nip if it is handled carelessly. It is a very fast mover when disturbed and apart from its general colouring it can be recognised by its red eyes, the velvety texture of it carapace and the back legs, which are flattened for swimming.

COLOUR Dark reddish-brown with blue on the legs.
CARAPACE LENGTH 65 mm.
HABITAT Under rocks and stones on the lower shore.
RANGE West and south coasts.
SIMILAR SPECIES Other crabs.

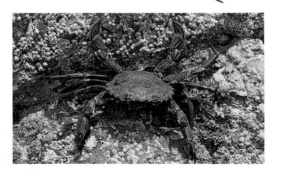

Shore Crab

Carcinus maenas

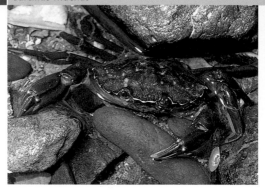

By far the commonest crab around our shores. It shows considerable variation in colour and is sometimes patterned; juveniles are even more variable. You may turn over a rock and find it sitting with what appears to be another crab which is dead. If you touch the living crab you will find that it is soft and the 'dead' crab is its cast-off skin.

COLOUR Most often dark green.
CARAPACE LENGTH To 60 mm.
HABITAT Mid-shore down on allkinds of shore and estuaries.
RANGE All coasts.
SIMILAR SPECIES Other crabs.

This crab is much deeper-bodied than the only other common hair-covered crab, the broad-clawed porcelain, which lives in the same part of the shore. One very noticeable feature of the hairy crab is that its pairs of pincers are of unequal size, the one pair being half as big again as the other pair.

COLOUR Red-brown.
CARAPACE LENGTH To 15 mm.
HABITAT Lower shore under rocks and stones.
RANGE West and south coasts.

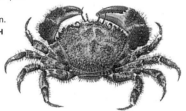

Xantho incisus

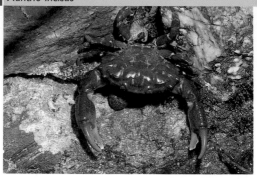

The furrowed crab gets its common name from the nature of its carapace, which is lined with a number of deep furrows. It is a very solidly built crab with very large pincers, which are black-tipped and can give a particularly nasty nip if the crab is not handled carefully.

COLOUR Red-brown.
CARAPACE LENGTH To 20 mm.
HABITAT Lower shore under rocks and stones.
RANGE South-west coasts.
SIMILAR SPECIES Other species in the same crab family.

Although not uncommon, the sea-spiders are not easy to spot as they tend to hide among weeds when the tide is out. Once found, their four pairs of legs provide a sure identification. They are very slow moving, walking with great deliberation, much like a sloth

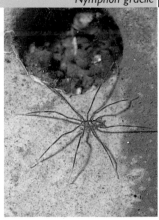

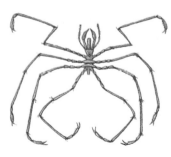

COLOUR Reddish.
LENGTH To 8 mm.
HABITAT Under stones and among seaweeds, middle shore down.
RANGE All coasts.
SIMILAR SPECIES Other species of sea-spider.

Anurida maritima

Although there are many insects living above the high tide line there are relatively few world-wide which can survive submersion by seawater. The rockpool springtail is most often found floating in rafts of a few to many individuals on the surface of pools. As the tide comes in they make their way into rock crevices until it retreats again.

COLOUR Blue.
LENGTH To 3 mm.
HABITAT Rock crevices and on surface of rockpools, mid-shore up.
RANGE All coasts.

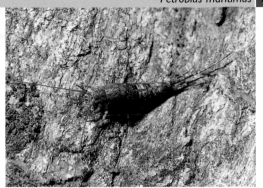

The bristletails are extremely primitive
insects totally lacking wings. They can be
found running around on rocks anywhere
from sea level up onto cliffs and in caves
above the sea, often occurring in
considerable numbers. When disturbed
they have the ability to jump a considerable
distance to avoid possible danger.

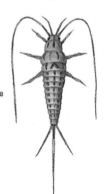

COLOUR Mottled dark grey-brown.
LENGTH To 15 mm.
HABITAT Rocks above the tideline.
RANGE All coasts.

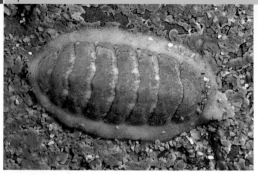

The name chiton is interchangeable with coat-of-mail shell, for the shells of these molluscs consist of a series of interlocking plates, akin to the chain mail of knights of old. The common chiton is to be found on almost any part of the shore clinging firmly to rocks and stones when the tide is out.

COLOUR Red, brown, greenish-grey or even blue.
LENGTH To 25 mm.
HABITAT On rocks on the shore.
RANGE All coasts.
SIMILAR SPECIES Other chitons.

Not easily distinguishable from the common chiton without using a lens, when close examination will reveal the raised keels on the shell plates. On the girdle surrounding the plates are evenly spaced patches of stiff bristles which show up as a series of white patches.

COLOUR Grey-green sometimes with darker markings.
LENGTH To 30 mm.
HABITAT On rocks.
RANGE All coasts.
SIMILAR SPECIES Other chitons.

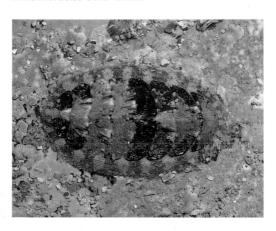

Common Limpet

Patella vulgata

Although there are similar-looking limpets the common limpet is the one you are most likely to encounter. Limpets tend to return to the same resting place following a session of feeding, during which the graze on algae encrusting the rocks on which they live. Look out, therefore, for the depressions that they leave in the surface of softer rocks denoting their normal resting place.

COLOUR Grey with darker markings, which are often worn off.
LENGTH To 60 mm.
HABITAT On rocks.
RANGE All coasts.
SIMILAR SPECIES Other species of *Patella*.

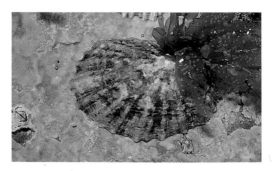

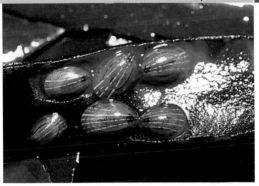

Instantly recognisable, you will only find this
limpet when the tide is at its lowest, when
it should be searched for on the stems
and blades of kelps such as oarweed. It
usually occurs in small groups and, like
the common limpet, lives in a groove
which it excavates in the stem of the plant
on which it lives.

COLOUR Translucent yellowish with rows of blue spots.
LENGTH To 15 mm.
HABITAT Lower shore on kelps.
RANGE All coasts.

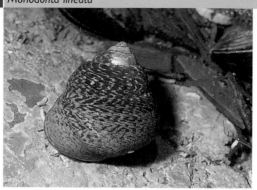

With its habit of sitting around on the rocks of the middle shore when the tide is out the toothed topshell can give the appearance of being extremely abundant. Although when young the tip of the shell may be quite angular, with age it wears away, becoming more rounded and revealing the shiny 'mother-of-pearl' beneath.

COLOUR Greyish with purple streaks.
HEIGHT To 30 mm.
HABITAT On rocks, middle shore.
RANGE The south-west and Wales.
SIMILAR SPECIES Other topshells.

Whereas the similar thick and flat topshells are
often found sitting out on the rocks, you will
have to search for the grey topshell, which
retires beneath stones and into rock
crevices when the tide recedes. It is
distinguished from the former two species
by the much finer patterning on its shell.

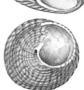

COLOUR Pale grey with darker stripes.
HEIGHT To 15 mm.
HABITAT Middle shore down, under
stones when the tide is out.
RANGE All coasts.
SIMILAR SPECIES Other topshells.

Flat Topshell

Gibbula umbilicalis

The shell of this species if somewhat flatter and more rounded, which helps to distinguish it from the larger thick topshell, though like the latter, areas at the top of the shell get worn away in the same way to reveal the pearliness beneath.

COLOUR Cream or greenish with reddish-purple stripes.
HEIGHT To 15 mm.
HABITAT Middle shore on rocks and in pools.
RANGE Mainly south-western.
SIMILAR SPECIES Other topshells.

One of our prettier molluscs, the painted topshell
should be searched for under rock overhangs,
under large stones and amongst seaweeds
when the tide is right out. Its sharply-
pointed shell distinguishes it from other
topshells and it is usually found in less
abundance than them.

COLOUR White, yellow or
pinkish with red streaks.
HEIGHT To 30 mm.
HABITAT Lower shore,
on rocks.
RANGE All coasts.

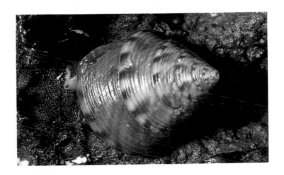

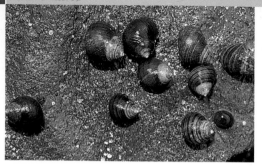

If you see men and women with buckets diligently searching across rocky shores, then it is almost certainly edible winkles that they are collecting. This is the largest of our periwinkles and it may often be active when the tide is out, moving slowly across the rocks or seaweeds on which it feeds.

COLOUR Dark grey to black, sometimes reddish.

HEIGHT To 30 mm.

HABITAT Middle shore down.

RANGE All coasts.

SIMILAR SPECIES Rough periwinkle resembles young common periwinkles.

The flat periwinkle is easily distinguished from the other winkles by the nearly flat top to its shell, the tip, or spire, just emerging above the main whorl, or turn. It resembles in size and colour the bladders on the wracks on which it lives, so achieves some degree of camouflage, though it may also be found on rocks.

COLOUR Dark brown to blackish, yellow, orange, red, purplish or green.
HEIGHT To 15 mm.
HABITAT Mainly middle shore, on wracks.
RANGE All coasts.

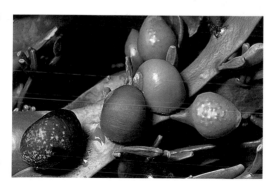

Small Periwinkle

Littorina neritoides

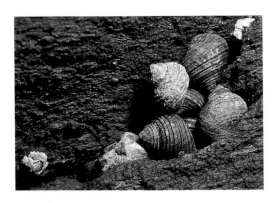

These are the tiniest of our periwinkles and when the tide recedes they make their way into rock crevices around the high tide line. You may find 20 or more of them crammed together into a tiny space and apart from their small size they have a sort of bloom on the surface of the shell.

COLOUR Dark grey.
HEIGHT To 10 mm.
HABITAT Rocks at the top of the shore.
RANGE All coasts.
SIMILAR SPECIES Rough periwinkle.

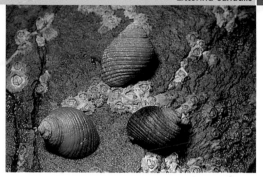

Rough periwinkles live in the area of the shore immediately below the previous species but, apart from their larger size, their main distinguishing feature is that they have spiral grooves in their shells making them feel very rough to the touch. They usually occur in ones and twos or in small groups.

COLOUR Red, orange or black.
HEIGHT To 18 mm.
HABITAT On rocks among the upper shore wracks, also on estuarine mud.
RANGE All coasts.
SIMILAR SPECIES Young resemble the small periwinkle.

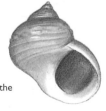

Spotted Cowrie

Trivia monacha

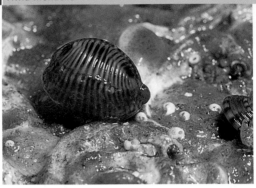

It may come as a surprise to find that cowries, more often associated with tropical seas, are also found around our shores. Ours, however, are very small and take some searching for under rock overhangs at the bottom of the shore. They often continue to move around when the tide is out when their orange, red or yellow body is clearly visible.

COLOUR White with brown spots.
LENGTH To 12 mm.
HABITAT Lower shore on rocky coasts.
RANGE All coasts.
SIMILAR SPECIES The Arctic cowrie, which is smaller and lacks spots.

Dog whelks are very common wherever their barnacle or mussel prey occur and in the summer they may often be found in company with clumps of their characteristic pale yellow to pinkish, flask-shaped egg-capsules. Individuals which feed on mussels are normally darker in colour than those which feed on barnacles.

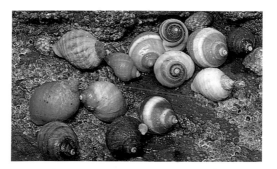

COLOUR Greyish-white to yellow, dark brown, often banded.
HEIGHT To 40 mm, sometimes more.
HABITAT Rocky shores, often in rock crevices.
RANGE All coasts.

Hinia reticulata

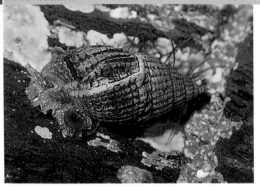

Distinguished from the dog whelk by both its habits
and its much thicker, heavier and more pointed shell.
The shell is deeply grooved, giving the appearance
of rough brickwork, and it is normally found
under stones in areas of sand and gravel
between rocky areas where the rocks lead
down to sand.

COLOUR Pale brown.
HEIGHT To 30 mm.
HABITAT Lower shore.
RANGE All coasts.
SIMILAR SPECIES Other *Hinia* whelks.

The thick-lipped is very similar in appearance to the netted dog whelk but is only half its size and is darker brown. It is found under stones on the lower shore, often in quite good numbers, and when the stone is lifted it will emerge from its shell and move off at some speed to seek shelter away from the light.

COLOUR Brown.
HEIGHT To 12 mm.
HABITAT Lower shore under stones.
RANGE All coasts.
SIMILAR SPECIES Other *Hinia* whelks.

Aplysia punctata

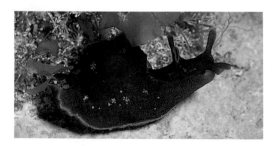

Named after its long tentacles, which resemble hare's ears, the sea-hare spends most of its life in deeper water below the lowest tide levels. It is included here because it comes up the shore in summer to spawn and in some years it can occur in enormous numbers on the seaweeds on which it lays its long strings of orange or pink eggs.

COLOUR Reddish, brownish or greenish, depending on age, with spotting.
LENGTH To 70 mm.
HABITAT Among seaweeds.
RANGE All coasts.

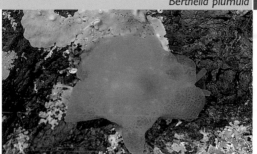

What at first appears to be a large blob of yellow or pale orange jelly attached to the under surface of a rock may well turn out to be this sea slug. To get a better appreciation of its true appearance it may be removed temporarily to a small pool. It will then extrude its head and tentacles and begin moving. Place it back beneath the rock when you have finished with it.

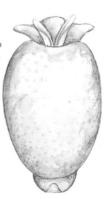

COLOUR Yellow.
LENGTH To 60 mm.
HABITAT On and under rocks on the lower shore.
RANGE All coasts.

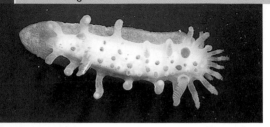

This is one of the more common of a number of interestingly shaped and often brightly coloured sea slugs which inhabit our shore. They are seldom found in large numbers and are usually revealed by diligent searching among seaweeds on the lower shore. As with all sea slugs they need to be under water for us to appreciate their full beauty.

COLOUR White with yellow and orange markings.
LENGTH To 18 mm.
HABITAT Lower shore on rocks.
RANGE All coasts.
SIMILAR SPECIES Other sea slugs.

One of our largest sea slugs, it is not uncommon and may be found by turning over large stones and by looking under rocky overhangs and in large crevices, especially in the vicinity of breadcrumb sponges, its main food. In water, the tuft of feathery gills on the rear end of the body becomes readily apparent.

COLOUR Yellow.
LENGTH To 120 mm.
HABITAT Rocky shores.
RANGE All coasts.
SIMILAR SPECIES Other sea slugs.

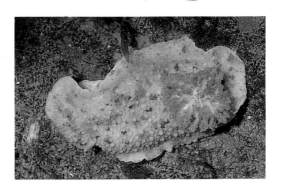

Aeolidia papillosa

Our other common, large sea slug, at first glance it appears to be covered in a dense layer of fur. The 'fur' is in fact a dense layer of short, thick, hair-like structures called cerata, which clothe the upper side of the animal's body. It is found wherever its main food, sea anemones, is found.

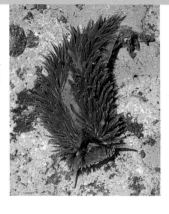

COLOUR Brownish-grey or sometimes greenish.
LENGTH To 120 mm.
HABITAT Rocky shores between high and low tide-marks.
RANGE All coasts.
SIMILAR SPECIES None this size or colour.

The mussel is one of the few bivalves that you are likely to come across during a general ramble on the shore. Most of the others live below sand and are difficult to find. Mussels usually occur in thousands covering the rocks to the exclusion of other creatures. The largest individuals, which are collected for food, are usually found in deeper water.

COLOUR Dark bluish or purplish.
LENGTH To 100 mm.
HABITAT Rocks on the
middle shore down.
RANGE All coasts.
SIMILAR SPECIES Other
mussels.

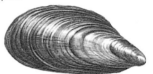

If anything, sea mats resemble a very fine sheet of bubble-wrap anchored to the surface of a seaweed. A sea mat is, in fact, a colony of animals with each 'bubble' on the sheet representing a single, microscopic animal. When covered in seawater the sea mat may appear furry, the 'fur' being the tentacles of the individual colony members.

COLOUR Transparent white.
HABITAT On fronds of saw wrack.
RANGE All coasts.
SIMILAR SPECIES Other sea mats.

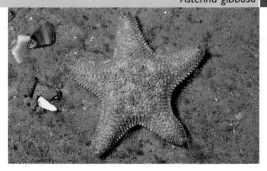

Where it occurs this is our only common short-armed starfish. It is found under rocks and among seaweeds when the tide is out. It has an unusual life-cycle, maturing as a male when it is 2 years old, becoming a female at 4 years and living for up to 7 years.

COLOUR Green or brown, may be mottled.
DIAMETER To 50 mm.
HABITAT Lower shore on rocks.
RANGE South and west coasts.

Common Starfish

Asterias rubens

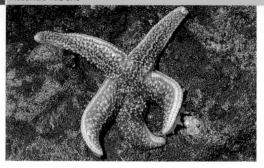

Rightfully called 'common' for in some years on some coasts it can occur in huge numbers. It can be found on almost any kind of shore, even getting into estuaries, but is most likely to be seen among seaweeds and under rock overhangs when the tide is out. It feeds on bivalves, worms and various other small creatures.

COLOUR Reddish or brownish, sometimes violet.

DIAMETER To 500 mm.

HABITAT Middle shore down.

RANGE All coasts.

SIMILAR SPECIES Other starfish.

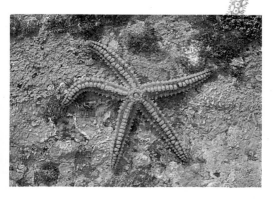

Although the largest specimens of this starfish occur below the lowest tide levels, large specimens may be found in pools and under rocks on the lower shore. Its most obvious identification feature are the rows of pointed spines along its arms. Apart from shellfish it also feeds on the common starfish.

COLOUR Variable; grey, green, yellow to reddish.
DIAMETER To 700 mm.
HABITAT Lower shore.
RANGE South and west coasts.

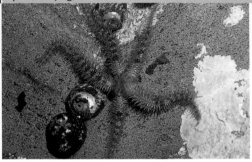

Brittle-stars differ from starfish proper in that they have an obvious circular central disc from which arise the five thin, very flexible arms, which break easily, hence the name. They often turn up in very large numbers under stones lying on gravel and rough sand between large rocks.

COLOUR Grey, yellow, red-brown, violet, purple, often spotted with red.

DIAMETER Disc to 20 mm.

HABITAT Lower shore.

RANGE All coasts.

SIMILAR SPECIES Other brittle-stars.

The commonest of the sea urchins to be found between the tides, it feeds on young barnacles and sea squirts. When the tide is out it is to be found by turning over rocks and stones but beware, it often hangs onto pieces of seaweed and broken shell with its sucking feet, camouflaging it and making it very difficult to spot.

COLOUR Green with violet-tipped spines.
DIAMETER To 50 mm.
HABITAT Rocks on the lower shore.
RANGE All coasts.
SIMILAR SPECIES Other sea urchins.

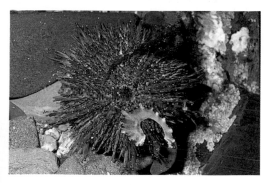

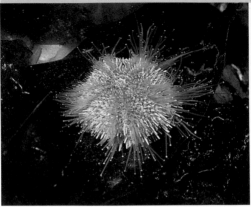

Normally found below the lowest water mark on the shore, the edible sea urchin can be found around the low water mark on occasions, especially during the spring. It is much fatter and more brightly coloured than the previous species and unfortunately gets collected for its ornamental test by skin divers.

COLOUR Red, spines white or red with purple tips.
DIAMETER To 180 mm.
HABITAT Lower shore on rocks.
RANGE All coasts.
SIMILAR SPECIES Other sea urchins.

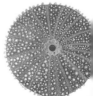

Although not common, this species is included here because if you find one you will almost certainly wonder what it is. In appearance it resembles one of those prickly, short, fat ridge cucumbers but is black rather than green. If handled it may exude sticky, white threads, like cotton, hence its common name.

COLOUR Dark brown.
LENGTH 200 mm or more.
HABITAT Lower shore on rocky coasts.
RANGE South-west coasts only.

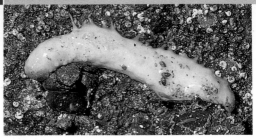

The sea gherkin should be searched for on the lower shore under large stones, in the holdfasts of the larger kelps and in rock crevices. Even with the tide out it will protrude its dark, tentacle-ringed head end, which contrasts markedly with its pale, worm-like body.

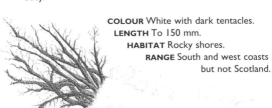

COLOUR White with dark tentacles.
LENGTH To 150 mm.
HABITAT Rocky shores.
RANGE South and west coasts but not Scotland.

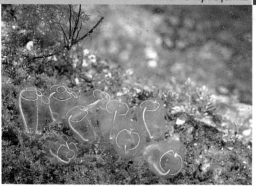

Looking for all the world like a collection of tiny light-bulbs, this sea squirt forms colonies of 20 or more individuals which are joined together at their bases by a common, root-like stolon which is attached to the rock on which they live. They are most often found under rock overhangs.

COLOUR Transparent with white lines.
HEIGHT To 20 mm.
HABITAT Lower shore on rocks.
RANGE All coasts.

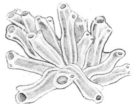

Dendrodoa grossularia

At first glance this sea squirt resembles patches of red fungus attached to rocks and stones and to the bases of kelps. Each individual is rather flattened, roughly oval in shape with two obvious openings, the entrance and exit to the canal, through which water is pumped to obtain its food.

COLOUR Deep red.
HEIGHT To 15 mm.
HABITAT Lower shore on rocks etc.
RANGE All coasts.
SIMILAR SPECIES Other red sea squirts.

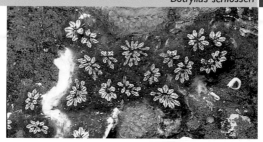

A rather thin,
encrusting sea
squirt forming
quite large colonies,
often beautifully
coloured. Each arm of the 'star' represents a single
individual within the colony, which has its own
mouth opening but shares a common exhalant
opening with the other members of the star. A
single sheet may contain many stars. In *Botrylloides
leachi* there are double rows of individuals forming
bands along either side of a common exhalant siphon.

COLOUR Orange, blue, yellow, purple.
HABITAT Rocks on the lower shore.
RANGE All coasts.
SIMILAR SPECIES The colonial sea squirt, *Botrylloides leachi*.

Ciliata mustela

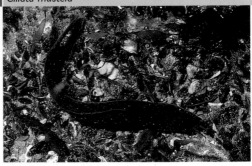

A long, slim, rather eel-like fish with a more flattened body than the eel. Its most easily observed characteristics are the five sensory barbels which protrude from the front of its face, rather in the manner of a catfish, which it uses when searching for food. It should be looked for under stones, especially in pools.

COLOUR Dark reddish-brown to almost black.
LENGTH To 200 mm.
HABITAT Rocky or sandy shores.
RANGE All coasts.
SIMILAR SPECIES 3-bearded rockling.

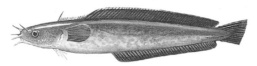

Relatives of the seahorses, pipefish, as their name
implies, are very long and thin. The head has
a long snout at the end of which is
the tiny mouth which they
use to suck up their
tiny planktonic food.
The worm pipefish
is not uncommon
and hides under
rocks and
stones when
the tide is
out.

COLOUR Dark brown.
LENGTH To 150 mm.
HABITAT Lower parts of rocky shores.
RANGE All coasts but more common
in south-west.
SIMILAR SPECIES Other pipefish.

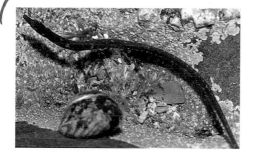

Centronotus gunnellus

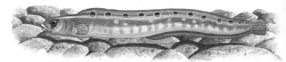

So-named because it is extremely slippery and very difficult to keep hold of. It is very easy to recognise for, apart from its rather eel-like shape, it has, along the base of the dorsal fin, a row of 12 equally spaced out dark spots with a white outline. It is usually found by carefully searching under rocks and stones.

COLOUR Bronze-brown.
LENGTH To 250 mm.
HABITAT Mainly lower down on rocky shores.
RANGE All coasts.

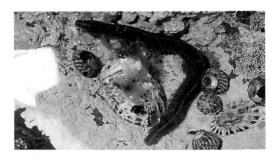

The father lasher is very similar in appearance to the bullhead of our streams and shallow rivers. It is most often found under stones in rockpools and if caught it should be handled with some care since it bears a number of spines which, although not poisonous, can scratch the skin quite unpleasantly.

COLOUR Brownish-grey.
LENGTH To 200 mm.
HABITAT Shallow water, only between tide-marks in the north.
RANGE All coasts but less common in the south.
SIMILAR SPECIES Long-spined sea scorpion.

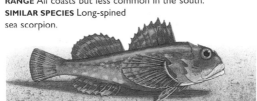

Rock Goby

Gobius paganellus

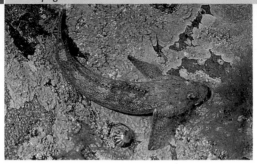

The gobies superficially resemble the blennies (p.123) but have a smaller head in relation to the body and the dorsal fin is divided into two distinct sections, features which can only be fully appreciated by carefully catching the fish and placing it in a clear-sided container. During the summer the female rock goby may be found protecting her large egg batches laid on the underside of a rock.

COLOUR
Brown.
LENGTH
To 120 mm.
HABITAT Rockpools.
RANGE South and west coasts, less common in the north.
SIMILAR SPECIES Other gobies.

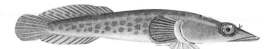

With its broad head, on top of which are two blue spots ringed in red or brown, and its mouth shaped somewhat like a duck's beak, the shore clingfish is immediately recognisable. If picked up it is not easy to put down again, for it has a sucker under the head with which it clings on quite tightly.

COLOUR Reddish brown.
LENGTH To 80 mm.
HABITAT Under stones on the lower shore.
RANGE West coasts, rare in Scotland.
SIMILAR SPECIES Other clingfish.

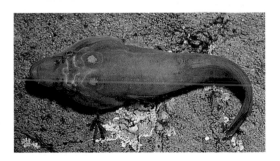

Sand and Shingle Beaches

A broad extent of shingle beach is about as unpopular with wildlife as it is with holidaymakers. Due to its unstable and very erosive nature, shingle is a hostile environment for most kinds of plants and animals. One of the few plants which is almost restricted to shingle is the yellow horned-poppy while others, such as sea kale, are also common on sand. The sparse animal life usually consists of a small but tough band of ground-dwelling spiders and insects.

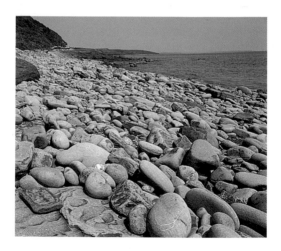

Ragworm

Nereis diversicolor

The ragworms are active creatures and although they usually
burrow in mud and sand they are able to swim as well. They have
an obvious head with eyespots and antennae and can
extrude a proboscis bearing a pair of teeth. The
large king ragworm from the lower shore is
actually able to deliver a painful bite and if
found should be handled with care.

COLOUR Orange brown, yellowish or
greenish.
LENGTH To 120 mm.
HABITAT Muddy sand.
RANGE All coasts.
SIMILAR SPECIES Other ragworms.

This worm is most likely to be encountered in the flesh if you come across a fisherman who is digging for them, for they are a favoured bait. Its presence in sand or mud is marked by the coiled casts lying on the surface, which have been exuded from its rear end during feeding. In the lugworm a circular depression in the sand, the 'blow-hole', shows where the mouth lies below the surface.

COLOUR Reddish-brown to pink with red gills.
LENGTH To 250 mm.
HABITAT Burrows in clean or muddy sand.
RANGE All coasts.
SIMILAR SPECIES Other *Arenicola* spp.

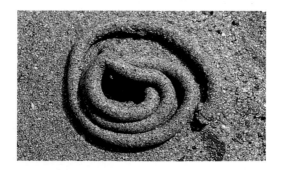

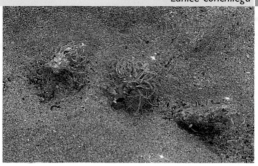

Like the previous species, the actual worm is only to be found by digging into the sand in which it dwells. What we find on the surface is the top of its burrow, which consists of particles of sand cemented together with mucus. Where large numbers of this species occur the masses of tree-like tube ends above the sand look like a miniature forest of dead trees.

COLOUR Pink, brown or yellow-brown.
LENGTH To 300 mm.
HABITAT Burrows in sand.
RANGE All coasts.

It is highly unlikely that you will encounter the actual worm, which builds the honeycomb-like colonies of sand tubes after which this species is named, unless it is in a pool, when a few individuals may stick their heads out even if the tide is out. The colonies are quite fragile and should not be stepped on.

COLOUR Pink.
LENGTH To 40 mm.
HABITAT Rocks on sand on the lower shore.
RANGE Most coasts.

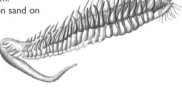

Sandhopper

Talitrus saltator

This and the other species of sandhoppers commonly found on the shore can exist in enormous numbers. They burrow into sand or live under piles of dead and decaying seaweed at the top of the shore and when disturbed they are able to either hop away at some speed or burrow rapidly into the sand.

COLOUR Brownish grey or greenish.
LENGTH To 25 mm.
HABITAT Upper shore on sand, often under debris.
RANGE All coasts.

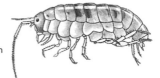

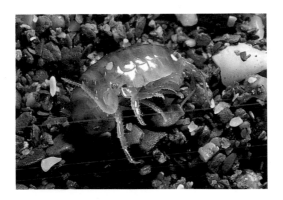

Brown or Edible Shrimp

Crangon crangon

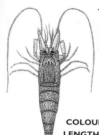

The shrimps may be distinguished from the similar prawns by their general body form, for shrimps are flattened from top to bottom whereas prawns tend to be flattened from side to side. They feed over the surface of sand and gravel and have the ability to rapidly wriggle their way into it to hide when they are threatened.

COLOUR Mottled grey to brown.
LENGTH To 90 mm.
HABITAT Lower shore in pools on sand.
RANGE All coasts.
SIMILAR SPECIES Other shrimps.

Pod Razor Shell

Ensis siliqua

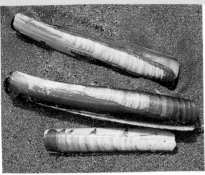

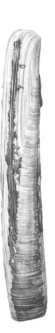

Razor shells live deep beneath the sand in permanent burrows, coming to the surface to feed when the tide comes in. You are most likely to find the washed up shells from dead animals but occasionally you may come across one which has not gone down its burrow as the tide has receded and can then be dug out. Placed on wet sand, it takes just a few seconds for it to dig itself back into the sand again.

COLOUR Yellow-brown.
LENGTH To 200 mm.
HABITAT Sandy shores.
RANGE All coasts.
SIMILAR SPECIES Other razor shells.

Echinocardium cordatum

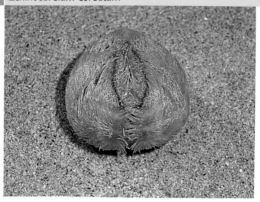

Since it normally lives under the sand it is most likely to be found after rough weather, when a number get washed up onto the shore and lie on the surface of the sand. They are roughly heart-shaped, the group as a whole being known as heart-urchins, and they are covered in a 'fur' of long, fine spines.

COLOUR Off-white.
LENGTH To 90 mm.
HABITAT Middle shore down, in sand.
RANGE All coasts.
SIMILAR SPECIES Other heart-urchins.

You are most likely to get a first sight of a dab as it skitters away from you across the bottom of a large pool on a sandy shore, leaving a trail of disturbed sand behind it as it does so. As soon as it stops again, it usually wriggles itself into the surface of the sand until only its eyes remain above the surface, so it takes a bit of finding.

COLOUR Brown.
LENGTH To 250 mm or more.
HABITAT Sandy shores and estuaries.
RANGE All coasts.
SIMILAR SPECIES Plaice and flounder.

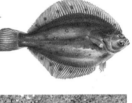

Lesser Sand Eel

Ammodytes tobianus

It is normally the juveniles of the sand eels that are found in-shore,
usually in pools on sandy shores, especially those around the base
of large rocks where the fish can seek shelter. They may also be
found along the edge of the sea and have the ability to bury
themselves in the sand if they are threatened. They are a very
important food for sea birds but unfortunately are now caught in
huge quantities to make fishmeal.

COLOUR Greenish above, silvery white underside.
LENGTH To 200 mm.
HABITAT Sandy bays.
RANGE All coasts.
SIMILAR SPECIES
Greater sand eel.

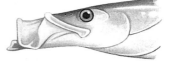

Common Blenny or Shanny

Lipophrys pholis

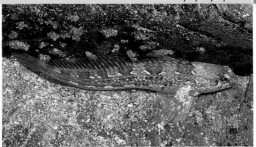

Along with the gobies, the blennies are the fish that are most likely to be seen shooting into a suitable hiding place in a rockpool when we disturb them. The common blenny has a large, blunt head and a tapering body along which the dorsal fin extends from behind the head almost to the tail fin.

COLOUR Variable, yellowish to greenish mottled with darker colours.
LENGTH To 130 mm.
HABITAT Among rocks, stones and seaweeds on most types of shore.
RANGE All coasts.
SIMILAR SPECIES Other blennies.

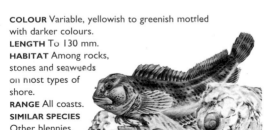

Shrubby Sea-blite

SAND AND SHINGLE

Suaeda vera

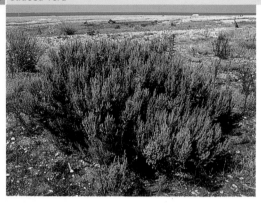

This evergreen bush has stout woody stems and forms a very compact plant compared with the rather lax and sprawling common seablite. The short leaves have rounded tips and are densely crowded on the stems. The small green flowers arise near the leaf-bases and have conspicuous yellow anthers and three stigmas.

FAMILY Chenopodiaceae.
HEIGHT 30–75 cm.
HABITAT On sand and shingle beaches and in the drier upper zones of saltmarshes.
RANGE Round the east coast from Dorset to Lincs.
FLOWERING TIME July–August.

The rather woody stems of prickly saltwort are somewhat prostrate forming a bushy plant which sprawls on the sand. The narrow, succulent leaves are arranged alternately up the stems and have a sharp spine at the tip from which the plant gets its common name. As with most members of the family Chenopodiaceae, the flowers are small and inconspicuous.

FAMILY Chenopodiaceae.
HEIGHT To 50 cm.
HABITAT Mostly on the strandline of sandy beaches.
RANGE All around the coast.
FLOWERING TIME July–September.

Yellow Horned-poppy

Glaucium flavum

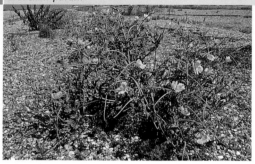

The branching stems of this attractive plant are a familiar sight on many shingle beaches. If broken, the stems exude a yellow latex. The bluish-grey leaves are deeply cut, with wavy edges. The pale yellow or yellowish-orange flowers reach a diameter of 9 cm and are followed by smooth, slender fruits that can be as much as 30 cm long.

FAMILY Papaveraceae.
HEIGHT 30–90 cm.
HABITAT Mainly on shingle beaches, sometimes on sand or rocks.
RANGE Scattered around all coasts except for northern Scotland.
FLOWERING TIME
June–September.

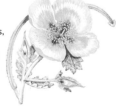

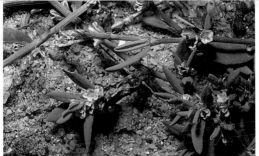

This is a neater, more compact and somewhat more robust plant than the familiar knotgrass (*P. aviculare*) with which it often grows. The flowers in Ray's knotgrass are also larger, whiter and much prettier. The one sure difference lies in the fruit, which in this species is mahogany-brown and projects well out from the old dead flower.

FAMILY Polygonaceae.
HEIGHT 2–10 cm.
HABITAT On sandy beaches.
RANGE Very scattered on all except eastern coasts, where it is mostly absent.
FLOWERING TIME August–October.
SIMILAR SPECIES In knotgrass the fruit is covered with the remains of the old flower.

Sea Rocket

Cakile maritima

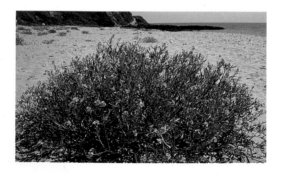

A bushy, often rather sprawling member of the cabbage family which is the only plant of the shore-line that has a combination of shiny, multi-lobed leaves and very pale lilac flowers. As with many seaside plants, the leaves tend to be rather fleshy. The seed-pods are shaped rather like egg-timers, in which the upper part is fattest.

FAMILY Brassicaceae.
HEIGHT 10–50 cm.
HABITAT On the drift-line of sandy beaches, sometimes on shingle.
RANGE All coasts.
FLOWERING TIME June–August.

Sea Kale

Crambe maritima

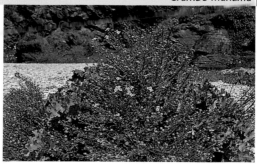

This handsome, much-branched, cabbage-like plant is the ancestor of the garden vegetable. The broad, waxy and very fleshy leaves are an attractive shade of bluish grey and have very crinkly, lobed margins. The stout stems have woody bases and often form large clumps, topped by the white flowers in broad and rather open clusters. The small seed pods are more or less spherical.

FAMILY Brassicaceae.
HEIGHT 30–75 cm.
HABITAT Mainly on shingle but also commonly at the tops of sandy beaches.
RANGE Very scattered around the coasts, northward to central Scotland.
FLOWERING TIME June–August.

Sea Radish

Raphanus raphanistrum ssp maritimus

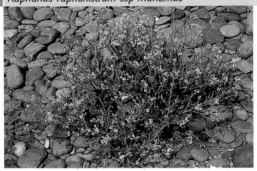

The leaves of this bushy plant are coarse and very rough. Flowers are yellow, except in the Channel Islands or in hybrids with wild radish when they may be white. The fruit is shaped like an hourglass.

FAMILY Brassicaceae.
HEIGHT 50–80 cm.
HABITAT Most common on shingle, the tops of sandy beaches and in waste places.
RANGE Mostly on the Atlantic coast, northward to north-west Scotland. Absent from most of the east coast.
FLOWERING TIME June–August.
SIMILAR SPECIES Wild radish (ssp *rhaphanistrum*) is finer, less branching with flowers white, pale lilac or pale yellow.

A dense thicket of this deciduous shrub can be a magnificent sight in autumn when the branches are laden with masses of glowing golden berries. The rather long, narrow leaves are thinly covered with a silvery meal on top, with brown undersides. The minute flowers occur in small clusters and are followed by bright orange, more or less globular fruits 6–10 mm in diameter.

FAMILY Elaeagnaceae.
HEIGHT 1.5–3 m.
HABITAT Sandy coasts.
RANGE All coasts but often planted, and possibly only native on the east coast of England.
FLOWERING TIME April–May.

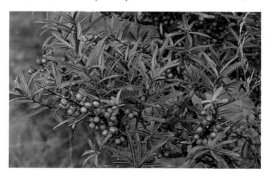

Strandline

One of the great joys of a walk by the sea is to search along the strandline to see what interesting things the sea has cast up on the shore. After storms, large quantities of kelp and other seaweeds may end up along the top of the shore, producing rather unpleasant smells as they rot but on the other hand providing important food and shelter for a number of small shore animals, as well as an excellent source of compost for those who have gardens near the coast. Many of the molluscs which live buried in sand are very difficult to find in life but their shells are washed up in great numbers, sometimes forming extensive beds. As these are ground down by the sea they form the sand which eventually gives rise to our coastal dune systems.

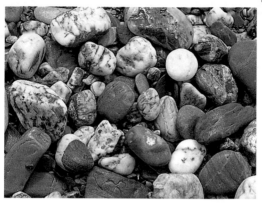

One of the great attractions of the coastline to many people is the great variety of shape, size and colour of the pebbles that make up many of our beaches. Each beach will vary depending upon the source of the pebbles, some coming from erosion of the local rocks, others being washed in from further along the coast by strong currents while others again may be ancient pebbles, formed many millions of years ago, and now exposed once more by the action of waves on the shore. Today, as a result of our activities, pebbles may also contain pieces of sea-worn glass and brick. The pebbles illustrated come from the shore at Seaton in Cornwall and include some, mainly the grey ones, derived from the rather soft local rocks.

Mermaid's Purse

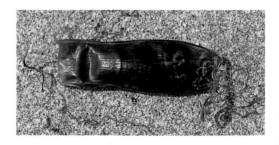

One thing worth searching for along the high tide mark is mermaid's purse, which has nothing to do with mermaids. It is, in fact, the egg case of one of our small sharks, or dogfish as they tend to be called, which frequent the shallower waters off-shore. These fish lay just a few, very large, yolky eggs surrounded by a tough outer casing, the mermaid's purse. A tendril at each of the four corners curls around the seaweed in which it is laid to anchor it there until the tiny shark hatches out. They vary in size, depending upon the species involved, and sometimes get washed up onto the shore intact during storms. Often, however, the case is broken open indicating that the young fish has hatched successfully.

Whelk Egg-case and Cuttlefish Bone

The edible common whelk is seldom encountered on the shore, as it lives below the lowest low tide line, though you may occasionally find one, identifiable by its large shell, up to 110 mm long. More often you will find its egg-cases, resembling a bunch of shrivelled grapes, (illustrated lying beside two cuttlefish bones),

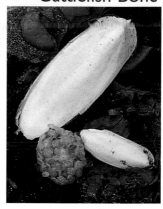

which get washed up onto the shore during storms. The cuttlefish is also seldom seen, since it lives in deeper water, though its bones, which are all that remains of the shell in this group of molluscs, are often washed up on the shore. Rather than protecting the animal on the outside, the bone of the cuttlefish supports the long, soft body. Look out for the little cuttlefish, which grows to just 20 mm long and may be taken in a net in sandy pools.

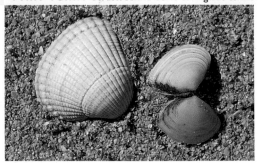

Common cockles, with their broadly oval shells, are sand-dwelling bivalves living from the middle shore downwards around all of our coasts. They are edible and cockle-digging is an important way of life for many coast dwellers. They are also an important source of food for oystercatchers and the bird may clash with man as a result. You are more likely to find cast-up cockle shells along the shore, though digging down a few inches into the sand will turn up the whole animal. Tellins also live beneath the sand and can be uncovered by digging but are of no importance to man as food. They have more elongated shells than cockles and the thin tellin in particular has a very thin, rather light and fragile shell and is often washed up along the shore in considerable numbers.

Thick Trough Shell

Spisula solida

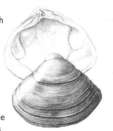

Like most bivalve molluscs the thick trough shell lives below sand and is common around most of the coast. It may be found by digging down a short distance but more often its shells get washed up on the shore and, along with the shells of thousands of other marine molluscs, they gradually get broken and ground down by the action of the sea to form shell-sand, the main constituent of our coastal sand dunes.

The shells, which grow up to 50 mm long and are very thick, are normally brown with darker lines, the brown being worn off when the animal dies. Like most bivalve molluscs the thick trough shell feeds by filtering small particles of food from the sea water.

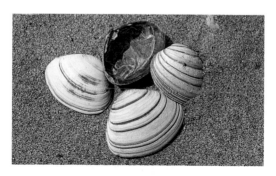

Sand-Dunes

Sand-dunes are usually very rich in wildlife. They consist of hillocks swept by the wind into a zone at the rear of a broad sandy beach. The slope facing the wind is normally quite gentle, while that away from the wind is much steeper. The shifting dunes nearest the sea are the 'yellow dunes', which include the fore-dunes directly behind the beach, while the stable ones further inland are the 'grey dunes'. The carpet of vegetation which anchors the sand in place is usually rather shallow, so it is easily damaged by human trampling. Once a breach has been opened, the wind can sneak in again and start nibbling away at the sand over a larger and larger area, causing a

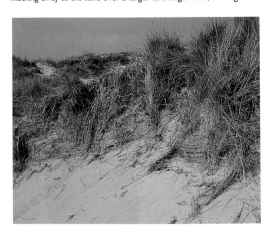

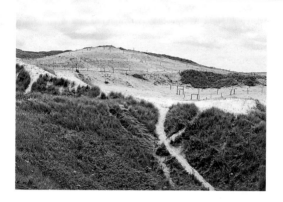

blowout. It is better to avoid such problems by behaving responsibly when on the dunes. The effects of trampling are well-illustrated below. Constant walking through the area by visitors on their way to and from the beach, or looking for shelter to picnic, have caused the sand to become unstable, forming a large blow-out. Always try to keep to existing paths, which fortunately often provide a good place to see wildlife, and do not enter fenced-off areas. In many of the very extensive dune-systems around the Welsh coast and elsewhere, the deepest hollows between the dunes become filled with water, especially in winter, and are known as slacks. These dry out appreciably in summer to form marshes, which are often full of orchids and other special plants.

This beautiful moss is one of the most characteristic mosses of sand-dunes, where it plays an important role in binding the sand, leading to the formation of the grey dunes. It forms extensive golden mats, overlain by a silvery sheen because each leaf ends in a long silver hair-point. Fruiting capsules are very rarely seen.

HEIGHT 0.2–1 cm.
HABITAT On both yellow and grey dunes.
RANGE All coasts; rare inland.

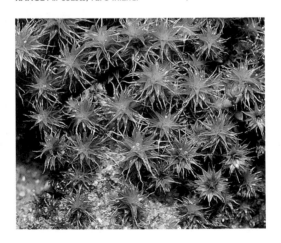

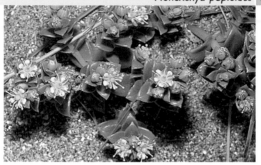

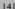

The thick, fleshy, yellowish-green, creeping mats of this plant are quite unlike any other. The tough, highly succulent leaves have pointed tips and are packed closely along the stems in neat rows. The tiny white flowers have narrow petals, shorter in the female flowers, which are often on a separate plant. The yellowish fruits resemble miniature peas.

FAMILY Caryopyllaceae.
HEIGHT 3–6 cm.
HABITAT In bare sand on the fore-dunes, often among marram; also on shingle.
RANGE Common on all coasts.
FLOWERING TIME May–July.

Sea Mouse-ear

142 *Cerastium diffusum*

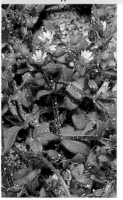

Sticky mats of this little plant often carpet the grey dunes, along with lichens and mosses. The very hairy stems are mainly prostrate and the leaves are almost oval, the upper ones with a normal margin. The white petals are slightly shorter than the green sepals, which are shorter than the fruit-stalks.

FAMILY Caryophyllaceae.
HEIGHT 5–10 cm.
HABITAT Grey dunes and very locally inland.
RANGE Common on all coasts.
FLOWERING TIME April–July.
SIMILAR SPECIES Common mouse-ear (*C. fontanum*) is taller and laxer, not sticky, the upper leaves white-margined, and with bigger flowers with deeply-cut petals.

Seaside Pansy

Viola tricolor ssp. curtisii

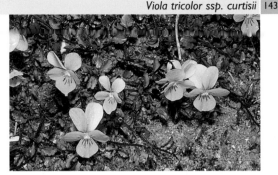

An attractive little plant which is a perennial with
well-developed underground stems buried in the
sand. The delicately beautiful flowers are usually
less than 25 mm across but are often produced in
considerable numbers. The petals can be either pure
yellow or purple, or a mixture of the two.

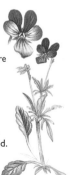

FAMILY Violaceae.
HEIGHT 5–15 cm.
HABITAT Grey dunes and also inland on
heaths in Norfolk and Suffolk.
RANGE Along western coasts, including Ireland.
FLOWERING TIME April–June.
SIMILAR SPECIES Several kinds of violets on
dunes but all have smaller, purple flowers.

Salix repens var. argentea

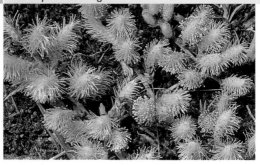

This is the only willow of lowland Britain that has a creeping rootstock. It is by far the smallest willow found on dunes, so cannot really be mistaken for anything else. The stems usually form a rather untidy sprawl and are downy, as are the leaves on both sides. The short, fat, yellow catkins arise from leafy stalks.

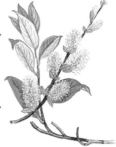

FAMILY Salicaceae.
HEIGHT 0.3–1.3 m.
HABITAT Dune-slacks.
RANGE Scattered around all coasts, commonest in the west.
FLOWERING TIME April–May, before leafing out.

Portland Spurge

Euphorbia portlandica

This attractive spurge is like a much larger
and greyer version of the familiar spurges
that can be annoying garden weeds. The
stems are often tinged red and like the whole
plant, are hairless. The rather leathery leaves are
tipped with a tiny point and have a prominent
midrib on the underside.

FAMILY Euphorbiaceae.
HEIGHT 10–50 cm.
HABITAT On the fore-dunes, often with
marram; also sometimes on cliffs.
RANGE Locally distributed along western coasts from
Hampshire to Galloway and around Ireland.
FLOWERING TIME April–September.

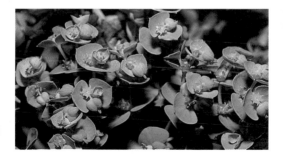

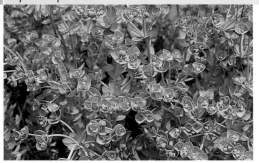

Sea spurge is like a more robust and even greyer version of the preceding species. The leaves are noticeably thicker and more succulent, lack the points on the tips and are arranged up the stem in a clasping fashion. The midrib on the underside of each leaf is also less prominent than in Portland spurge (p.145) and the stem never reddens.

FAMILY Euphorbiaceae.
HEIGHT 15–60 cm.
HABITAT Usually with Portland spurge.
RANGE From the coast of Norfolk, around the south and west coasts to Wigtown, and around Ireland.

Large-flowered Evening-Primrose

Oenothera glazioviana

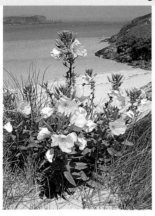

This graceful plant is often so abundant on dunes that it is difficult to believe that it does not belong here but was introduced from North America. It hybridises freely with other evening primroses, making identification tricky. However, the petals are wider than long and there are numerous red, bulbous-based hairs on the stems and fruits.

FAMILY Onagraceae.
HEIGHT 0.5–1.8 m.
HABITAT Drier spots on dunes, also inland in waste places such as sand-pits.
RANGE Widespread round all coasts except in north and central Scotland.
SIMILAR SPECIES Several other evening primroses but they are difficult to separate.

Common Stork's-bill

148 *Erodium cicutarium*

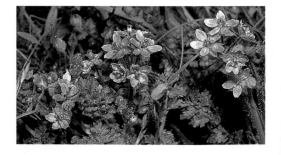

By far our commonest stork's-bill, it may be very abundant on dunes. It is always rather hairy but by the sea it is also generally sticky, such that the leaves are often covered with sand grains. The flowers are in small, rather open heads and vary in shade from white to deep pink. The seed-pod is long and pointed, like a stork's beak and is unpitted.

FAMILY Geraniaceae.

HEIGHT 5–10 cm.

HABITAT Bare dry spots on dunes and inland.

RANGE Locally scattered around most coasts.

SIMILAR SPECIES The rarer musk stork's-bill (*M. moschata*) is bigger and rougher, smells of musk, has deeper pink, more crowded flowers and pitted fruits.

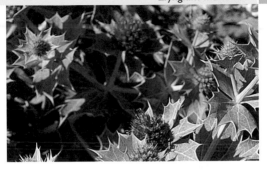

This distinctive plant is unrelated to true holly but
is, surprisingly enough, a member of the carrot
family. The shiny, almost plastic-like, bluish-
green leaves have white margins, while the
dense, globular flower-heads are a deep
and beautiful shade of pure blue. They are
much favoured by bees and burnet moths.

FAMILY Apiaceae.
HEIGHT 15–60 cm.
HABITAT On the fore-dunes, also common
on shingle.
RANGE All coasts but now almost extinct in the
north and in Scotland.
FLOWERING TIME July–August.

Sea Bindweed

Calystegia soldanella

The wire-like stems of this plant can be quite inconspicuous until the pink, bell-like flowers appear. Decorated with five white stripes these can reach 5.5 cm across. The rather small leaves are kidney-shaped and quite fleshy. The yellow flowers and succulent leaves in the illustration belong to biting stonecrop (*Sedum acre*).

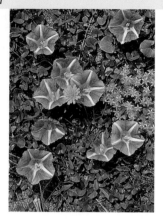

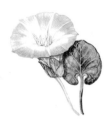

FAMILY Convolvulaceae.
LENGTH 1–3 m.
HABITAT On fore-dunes, sometimes on shingle.
RANGE All coasts, northward to central Scotland.
FLOWERING TIME June–August.
SIMILAR SPECIES Field bindweed (*Convolvulus arvensis*) has smaller leaves and flowers.

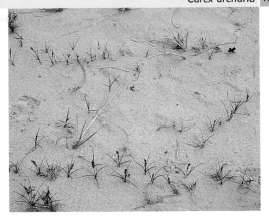

The above-ground portions of this small sedge typically appear in
lines, arising at regular intervals from the long, creeping,
underground stems. The visible stems are 3-angled, the
flowerspikes are unstalked and the fruits are quite large, with a
prominent beak and toothed wings.

FAMILY Cyperaceae.
HEIGHT 8–15 cm.
HABITAT Colonising the fore-dunes and on blowouts.
RANGE All coasts; more rarely inland.
FLOWERING TIME June–July.

Ammophila arenaria

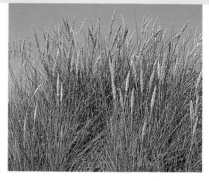

This stout grass is an important factor in the development of sand dunes because of its ability to continue to grow upwards through repeated coverings of sand. In this way the dunes grow higher and higher, until they stabilise and the marram is replaced by other plants. The leaves are broad and stiff and have sharp points, while the flower-heads are long and thick.

FAMILY Poaceae.
HEIGHT 0.3–1.5 m.
HABITAT Fore-dunes.
DISTRIBUTION Common on all coasts.
FLOWERING TIME July–August.

Sand cat's-tail is the most dainty and distinctive grass of the dunes.
The short, smooth, pale green leaves are tufted, surmounted by
plump, cigar-shaped, unbranched flower-heads up to 5 cm long but
often much shorter. Of all our cat's-tails, this is the only one that is
an annual.

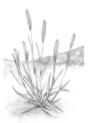

FAMILY Poaceae.
HEIGHT 3–20 cm (usually 5–8 cm)
HABITAT On grey dunes.
RANGE Common on all coasts except
north and west Scotland.
FLOWERING TIME May–July.
SIMILAR SPECIES Timothy grass (*P.
pratense*) is much taller (to 1–5 m) and
has longer flower-heads (5–15 cm).

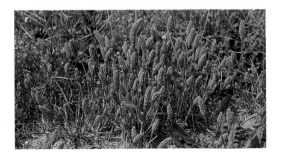

Sand Couch Grass

154 *Elytrigia juncea*

This greyish-green grass plays a front-line role in the formation of dune systems as it colonises the shifting sands of the first row of fore-dunes. Here it often forms a dense pure stand of stems and roots that anchor the sand in place. The leaves have downy ribs and the flower-heads have widely-spaced spikelets.

FAMILY Poaceae.
HEIGHT 30–80 cm.
HABITAT Only on the fore-dunes.
RANGE Common on all coasts.
FLOWERING TIME June–August.

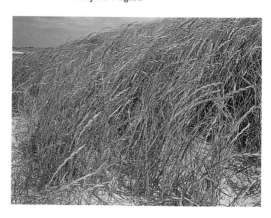

Lyme Grass

Leymus arenarius 155

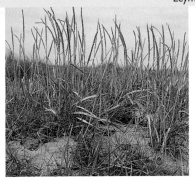

Lyme grass is fairly easily recognised by its very
greyish appearance and stiff, sharply pointed
leaves. Arranged in an alternating sequence up
each side of the very long, unbranched flower-
heads are pairs of unstalked, downy, multi-
flowered spikelets.

FAMILY Poaceae.
HEIGHT 0.6–1.2 m.
HABITAT On the fore-dunes, often with
marram.
RANGE Most coasts but absent from many
parts of southern English and Irish coasts.
FLOWERING TIME July–August

Stinking Iris

Iris foetidissima

A distinctive plant which is similar
to the garden irises. The broad,
bright green leaves grow in dense
tufts and the rather small flowers
are of an unusual shade of dull
greyish purple. When ripe, the
plump, green fruits split open to
reveal that they are crammed with
brilliant orange seeds.

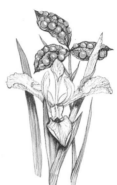

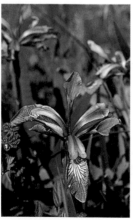

FAMILY Iridaceae.
HEIGHT 40–80 cm.
HABITAT Abundant locally
on dunes and clifftops.
RANGE Locally scattered
along coasts northward to
Norfolk and North Wales.
FLOWERING TIME June.
SIMILAR SPECIES Yellow
flag (*I. pseudacorus*) has
larger, bright yellow
flowers. It can be common
in damp spots on dunes.

Marsh Helleborine

Epipactis palustris

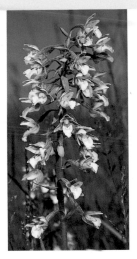

In the last 40 years this lovely orchid has decreased so much in its inland localities that dune slacks are undoubtedly now the best place to admire it. Indeed, here it can be very easy, as the plants often occur in their thousands. No other wild flower is really at all similar, so close study of the illustration should be all that is needed for identification.

FAMILY Orchidaceae.
HEIGHT 12–45 cm.
HABITAT Dune slacks and more rarely in marshes and fens inland.
RANGE Scattered along coasts northward to central Scotland; widespread around Ireland.
FLOWERING TIME July–August.

Pyramidal Orchid

Our only orchid with a densely crowded flower-spike, pyramid-shaped in its early stages and plumply dome-shaped later on. As the lower flowers die off the spike can become quite elongated. The flowers vary from deep, bright purplish-pink to quite a pale pink and have a long, slender spur.

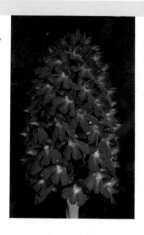

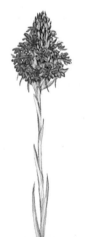

FAMILY Orchidaceae.
HEIGHT 15–45 cm.
HABITAT Drier parts of dunes and on grassy clifftops.
RANGE Scattered, along all coasts northward to southern Scotland, but commonest in the south and east; widespread around Ireland.
FLOWERING TIME July–August.

When present in large numbers this orchid can present a spectacular sight in some dune slacks, especially in Wales. The bright green, smooth, rather shiny leaves are fairly narrow and always unspotted. The flower-spike is quite short and squat and contains a crowded mass of flowers in a unique (for our orchids) shade of brick red.

FAMILY Orchidaceae.
HEIGHT 15–20 cm.
HABITAT Dune slacks.
RANGE Common round Ireland; otherwise mainly western, northward to Shetland. On the east coast only in the north, where it is rare.
FLOWERING TIME May–July.

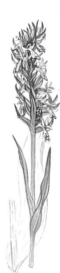

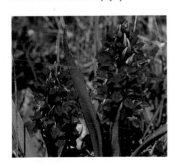

Sandhill Snail

Theba pisana

Really a Mediterranean species, this snail was probably accidentally introduced into Britain near St Ives in Cornwall around 1797. Since then it has spread along the north Cornish coast and into Wales. Although therefore very local, it is often present in very large numbers, clinging to the vegetation in great clusters during dry weather (as illustrated), hence its inclusion in this guide. It cannot really be mistaken for any other snail.

FAMILY Helicidae.
SHELL 12–25 mm across, 9–20 mm high.
HABITAT Dry areas on dunes.
RANGE Coasts of north Cornwall, South Wales and eastern Ireland.

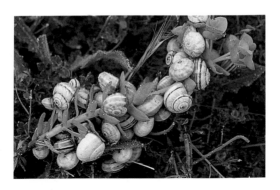

Cochlicella acuta

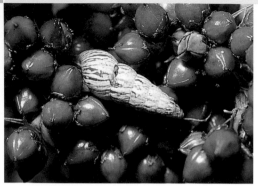

An easily recognised snail which is often common on dunes, fixed (often in small groups) to plants, bits of wood or even the shells of larger snails. The white or pale brown shell takes the form of a very elongated cone, often marked with bands or blotches of darker brown. The animal only comes out of its shell in wet weather or at night.

FAMILY Helicelidae.
SHELL 4–7 mm across, 10–20 mm high.
HABITAT Anywhere on dunes.
RANGE Scattered, mainly around Atlantic coasts, from Kent to northern Scotland, absent from the east coast. Common around Ireland and even inland.

This species is so well camouflaged against the sand that it is difficult to see unless it moves. The colour of the rather flattened body varies somewhat, although on dunes it is usually more or less as in the specimen illustrated (a female). The legs are always conspicuously decorated with light and dark rings. The spiders spend much of their time in burrows in the sand but can also be seen running actively around, hunting for prey.

FAMILY Lycosidae.
LENGTH of body 5–9 mm.
HABITAT Dry parts of dunes.
RANGE Widespread and common round all coasts.
SEASON Adults can be seen from April–October.

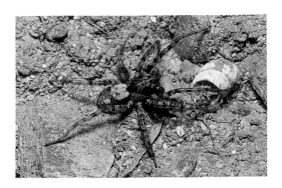

Xerolycosa miniata

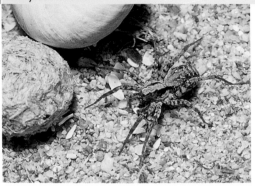

This species is fairly easily distinguished from the previous one by the dark sides to the cephalothorax (behind the head) and the pale chevrons on the abdomen. It is much paler than some of the common dark brown or blackish wolf spiders in the genus *Pardosa*, found on dunes. The female (illustrated) can often be seen carrying a white egg-sack attached beneath the rear of her body. The males look very similar.

FAMILY Lycosidae.
LENGTH of body 4.5–7 mm.
HABITAT Mainly on the grey dunes.
RANGE Widespread around most coasts.
SEASON Adults can be seen from about May until August.

Grass Spider

Tibellus oblongus

This long, slim, straw-coloured spider is usually found stretched out on a flower or with its narrow body placed lengthwise down a plant stem. From this ambush position it can jump out with great agility to pounce on passing insects. From July the females can be found standing guard over their white egg-sacs on grasses and other plants.

FAMILY Thomisidae.
LENGTH of body 8–9 mm.
HABITAT Among long grasses on dunes but more common inland.
RANGE Common around all coasts.
SEASON Adults are usually seen in July and August.
SIMILAR SPECIES *T. maritimus* also occurs on dunes.

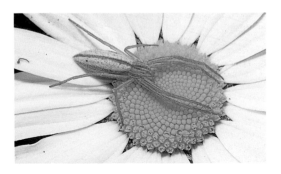

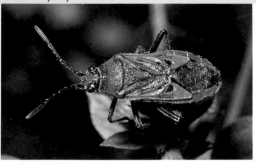

A bright red insect which is one of the most spectacular bugs found in the British Isles, its vivid coloration standing out among the majority of drabber bugs that tend to be so common. It is usually found singly on a leaf or fruiting head but can occur in very large numbers on some dune systems. It feeds on a wide variety of plants.

FAMILY Rhopalidae.
LENGTH 9 mm.
HABITAT On dunes and clifftops, rarely far from the sea.
RANGE Coasts from Sussex to Wales and Lancashire and around south-east Ireland.
SEASON June–September

The dune spurge bug is one of only two representatives of this mainly tropical family in Britain. Any rather elongated, blackish bug found feeding on sea or Portland spurges on coastal dunes is likely to be this species. Note the antennae with their alternating black and white bands, the black and white legs and the noticeably pointed head.

FAMILY Stenocephalidae.
LENGTH 12–14 mm.
HABITAT Mainly on the fore-dunes where its spurge foodplants grow.
RANGE Scattered around the coast, from Kent to western Wales, and around southern Ireland.
SEASON June–July.

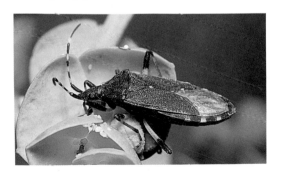

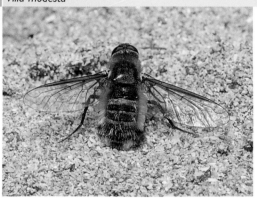

This plump and very hairy clear-winged fly can often be seen sitting on bare sand, especially along paths across the dunes. No similar-looking fly is likely to be present at the same season. The female (illustrated) is picking up sand-grains in a special pouch. She will use these to form a coating around her eggs, which she drops on the sand. The larvae parasitise moth caterpillars.

FAMILY Bombyliidae.
LENGTH 10–13 mm.
HABITAT Mainly on the grey dunes.
RANGE Scattered on most coasts.
SEASON July–September.

Fan-bristled Robber Fly

A very dark, stumpy robber fly with a noticeably 'hunch-backed'
appearance due to the very convex top of its thorax. It is
conspicuously hairy, with very spiny legs. It will take a variety of
other insects as prey, often sitting in the middle of paths while it
waits for a prospective meal to pass by. The eggs are laid in grasses.

FAMILY Asilidae.
LENGTH 10–16 mm.
HABITAT Mainly on grey dunes.
RANGE All coasts.
SEASON Late May–early July.
SIMILAR SPECIES The dune robberfly (*Philonicus albiceps*) is
pale grey, looks much slimmer and less hairy and flies in July
and August.

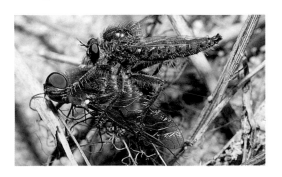

Only the male (illustrated) of this rather slim fly is covered in a
dense pelt of beautiful silver hairs. The females are much duller,
with shorter hairs. This must be a help when the female lays her
eggs, during which she forces most of her body backwards down
into the sand. The adults seldom if ever seem to feed, while the
subterranean larvae eat vegetable matter and (possibly) other small
animals.

FAMILY Therevidae.
LENGTH 8–11 mm.
HABITAT On bare sand of dunes; rare inland on heaths.
RANGE All coasts.
SEASON May–September.

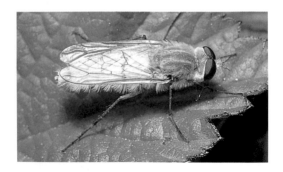

Sand Tailed-digger Wasp

Cerceris arenaria

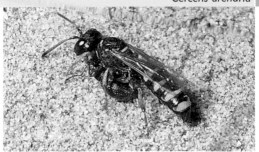

One of several common species of hunting wasps that can be very prominent on dunes. It is best recognised by its fairly large size and the constrictions between the abdominal segments, making the abdomen rather knobbly in appearance. The female preys on weevils, which she carries beneath her back to her nest in the sand.

FAMILY Sphecidae.
LENGTH 13–16 mm.
HABITAT Edges of paths, bare areas of sand.
RANGE Commonest along southern coasts, petering out northward to Yorkshire; absent from Ireland.
SEASON June–July.
SIMILAR SPECIES See slender-bodied digger.

Tachysphex pompiliformis

A common wasp which is one of several similar-looking species (not all in the same genus) that can only be reliably separated by an expert. However, this is the only one in which a female will be seen towing a paralysed grasshopper nymph across the sand back to her nest. The females can also be seen darting rapidly around on the dunes in warm weather, searching for prey.

FAMILY Sphecidae.
LENGTH 7–10 mm.
HABITAT Nests in bare, stable sand.
RANGE Scattered on all coasts except for the far north of Scotland; also in sandy places inland. In Ireland rare and only on the east coast (no recent records).

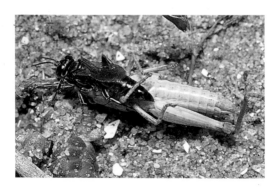

Common Sand Wasp

Ammophila sabulosa

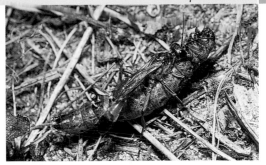

This large and impressive insect is notable for its
long, slim, black and red abdomen, which is held
upwards at an angle when the wasp is in flight.
Although most often seen looking for prey, the
females can also be found trundling back to the
nest after a successful hunt, with a large
caterpillar in tow, held snugly beneath the body.

FAMILY Sphecidae.
LENGTH 15–25 mm.
HABITAT Nests in stable, bare sand.
RANGE Mostly around southern coasts, very rare north of
Yorkshire. Very rare in Ireland, only on the south-east coast.
SIMILAR SPECIES The great sand wasp (*Podalonia hirsuta*) also
catches caterpillars.

Anoplius infuscatus

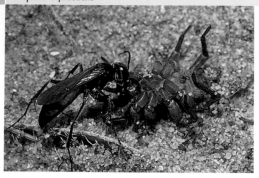

Another small, slim, black and red, solitary type that is common on dunes. Females are usually seen rushing around searching for prey, in this case spiders. After a successful hunt, the wasp stores the paralysed spider in a tuft of grass while she digs a nest burrow in the sand. A favourite prey is the sand wolf spider (*Arctosa perita*).

FAMILY Pompilidae.
LENGTH 8–10 mm.
HABITAT On grey dunes.
RANGE Coasts south of a line Southport to Grimsby; not Ireland.
SEASON June–August.
SIMILAR SPECIES *A. viaticus* is larger (10–15 mm), female has a rather bristly abdomen.

Creeping Willow Bee

Colletes cunicularius ssp celticus

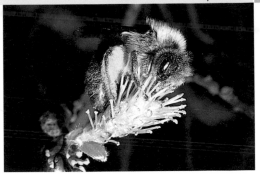

Although only locally distributed, this bee can occur in huge numbers where conditions are right, when vast nesting aggregations are formed. It can most easily be recognised by the fact that it is the only bee of sand-dunes which forages exclusively on the catkins of creeping willow early in the year. The males form 'mating balls' in their struggle to couple with emerging females.

FAMILY Colletidae.
LENGTH 9–11 mm.
HABITAT On flattish areas of grey dune.
RANGE Scattered around the coasts of south Wales and north-west England.
SEASON April–May.

Dune Snail Bee

Osmia aurulenta

The nesting habits of this attractive bee make it one of our most
interesting insects. Females nest inside empty snail shells, usually of
the common snail (*Helix aspersa*), which is often very abundant on
dunes. The densely hairy female (illustrated) is rusty brown but
males are black and less hairy.

FAMILY Megachilidae.
LENGTH 8–11 mm.
HABITAT Mainly on dunes.
RANGE Coasts from Kent to Cornwall, north to Galloway,
and along eastern Ireland.
SEASON May–June.
SIMILAR SPECIES The coast mason bee (*O. maritima*) is
13–14 mm long and nests in a wide variety of cavities, only
rarely in shells.

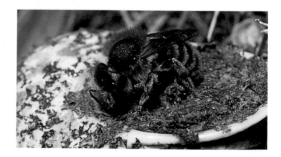

Silvery Leafcutter Bee

Megachile dorsalis

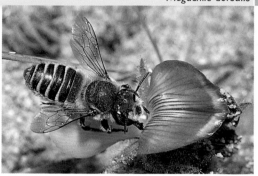

Smallest of several species of leafcutter bees on dunes. Females nest in burrows in the sand, forming large, bustling colonies on flat or slightly sloping ground, or in banks. They snip segments from leaves (often willows) with which to build a cell within the nest. The rusty brown males look quite different from the female illustrated.

FAMILY Megachilidae.
LENGTH 8–11 mm.
HABITAT Only on dunes.
RANGE Scattered around the south coast but usually abundant where found.
SEASON May–August.
SIMILAR SPECIES The coast leafcutter (*M. maritima*) is larger but with similar habits.

Hairy-legged Mining Bee

Dasypoda altercator

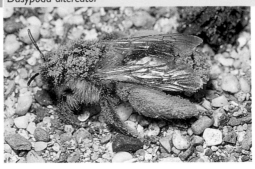

Females of this bee returning to the nest from a foraging trip are often so covered in pollen that it is difficult to see much of the bee. This is because this very hairy species is a 'whole body' collector, although the large pollen-baskets on the hind legs are also often swollen with large, yellow blobs. The nest is dug in sandy ground, often on or beside paths, and the females forage mainly on hawkweeds, knapweeds, etc.

FAMILY Andrenidae.
LENGTH 13–15 mm.
HABITAT On dunes and clifftops.
RANGE Locally distributed around the south coast from Norfolk to north Wales.
SEASON July–August.

This beetle often suddenly appears in large swarms as the males pursue the emerging females in warm sunshine. The wing-cases are shiny brown, while the thorax is green, with a broad, wavy, brown line forming the lowermost margins. The adults often sit inside flowers in cool weather, while the fat larva feeds on roots in the sand.

FAMILY Scarabaeidae.
LENGTH 12–15 mm.
HABITAT Only on dunes.
RANGE Distributed along southern coasts.
SEASON June–August.
SIMILAR SPECIES The garden chafer (*Phyllopertha horticola*) is similar but smaller (8–12 mm) and has an all-green thorax.

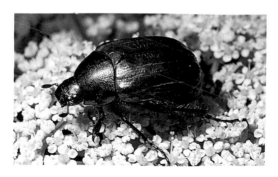

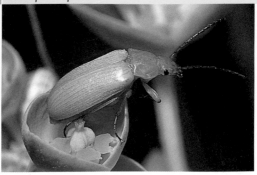

A small but very attractive beetle which is really like no other, so identification is easy. It often occurs in huge numbers on some dune systems, with up to 20 or more beetles thronging on a single head of sea carrot. The adults spend almost all their time feeding on pollen, while the larvae live in the sand at the bases of the plants.

FAMILY Alleculidae.
LENGTH 4–5 mm.
HABITAT Anywhere on dunes; more rarely inland.
RANGE Widespread around all coasts.
SEASON May–August.

Red Poplar Leaf Beetle

Chrysomela populi

The attractive red poplar leaf beetle can occur in huge numbers in dune slacks that are filled with creeping willow. The wing-cases vary from pale reddish brown to a bright rusty red, the latter being more typical of individuals that have emerged from hibernation in May. The pronotum (behind the head) is dark green or bronze. The larvae are bluish grey with orange spots and, like the adults, feed openly on willow leaves.

FAMILY Chrysomelidae.
LENGTH 8–10 mm.
HABITAT Mainly in slacks on dunes.
RANGE Widespread but scattered around all coasts.
SEASON May–August.

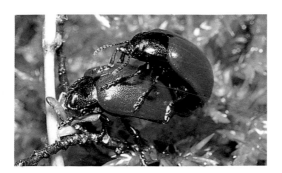

Otiorrhynchus atroapterus

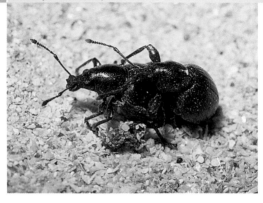

This quite large, shiny black weevil can often be seen walking around rather laboriously on the bare sand between clumps of marram on the fore-dunes. It has little choice but to walk, as it has no wings. The larvae live in the sand, where they feed on the roots of plants. Its long, downward-projecting snout easily distinguishes it from small, black ground beetles (Carabidae)

FAMILY Curculionidae.
LENGTH 7–9 mm.
HABITAT On the yellow dunes.
RANGE Widely distributed on dunes around all coasts.
SEASON May–June.

Saltmarshes and Brackish Meadows

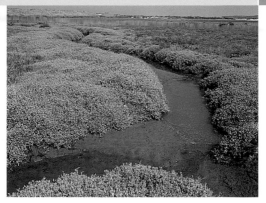

Saltmarshes are formed from silt washed down rivers, which is deposited at their mouths where they enter the sea. They also develop quite a long way inland on the muddy edges of tidal rivers. They are interesting places for the naturalist, being filled with a small but highly specialised array of plants and animals. Saltmarsh plants have to endure the twice-daily inundation by salty water, broken by long periods beneath a hot sun or under freezing conditions. They are highly specialised for this life, being tough customers with succulent stems, and their requirement for salty conditions gives them their name of halophytes. Resident animals are very small in number, as long alternating periods of immersion and exposure are more difficult for animals to endure.

Ranunculus baudotii

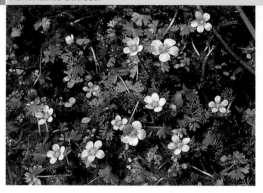

A sprawling plant which often fills ditches and ponds near the sea with a mass of leaves which include both floating and submerged forms. The floating form is shaped rather like a clover leaf, while the submerged form is rigid and resembles a bunch of branching threads. The small flowers are white with yellow centres.

FAMILY Ranunculaceae.
HEIGHT 2–5 cm.
HABITAT Usually in brackish ponds and ditches.
RANGE Scattered around all coasts.
FLOWERING TIME May–July.
SIMILAR SPECIES Several other white-flowered crowfoots occur but not in brackish water.

In contrast to the broadly triangular leaves of
the spear-leaved orache, in *A. littoralis* the leaves
are long and relatively narrow and grass-like, as
well as being noticeably fleshier. The flower-spike
also usually has fewer leaves intermixed with the
tiny, drab greenish flowers.

FAMILY Chenopodiaceae.
HEIGHT 30–70 cm.
HABITAT On beach-tops and the edges of
saltmarshes.
RANGE On most coasts but much commoner
in the east.
FLOWERING TIME July–September.

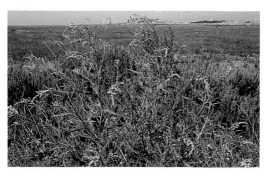

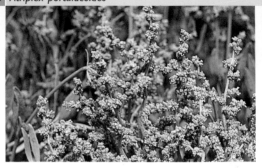

With its rather silvery-grey leaves and dull golden flower spikes this is one of the more attractive members of the goosefoot family, especially when it carpets a saltmarsh in thousands, as often happens. The brown stems are usually semi-prostrate and the mealy, elliptical leaves have untoothed margins.

FAMILY Chenopodiaceae.
HEIGHT 20–40 cm.
HABITAT Saltmarshes, often most abundant along the edges of saltwater creeks.
RANGE Most coasts except around northern Scotland; around Ireland only in the east.
FLOWERING TIME July–September.

Glassworts are among our strangest plants. The smooth, highly succulent stems bear no obvious signs of leaves. These are present but as fleshy sheaths fused to the stems. The plant is usually yellowish-green, often turning red in autumn. The minute flowers have no petals and are visible only as 1–2 yellow stamens protruding from the stems.

FAMILY Chenopodiaceae.
HEIGHT 10–50 cm.
HABITAT Anywhere in saltmarshes.
RANGE All coasts.
FLOWERING TIME August–September.
SIMILAR SPECIES Several more species of glassworts, often connected via hybrids to this species, which is by far the commonest.

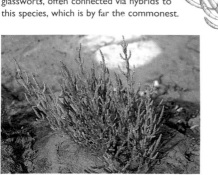

Suaeda maritima

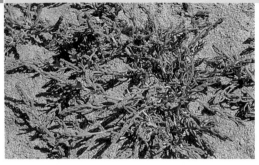

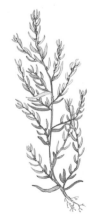

The short, straggly plants of annual sea-blite are a common sight sprawling on the mud of a saltmarsh when the tide has gone out. The thick, fleshy, bluish-green leaves are more or less narrowly cylindrical, with pointed tips. The tiny, greenish flowers have five yellow stamens and two stigmas.

FAMILY Chenopodiaceae.
LENGTH 9–30 cm.
HABITAT On the middle and lower parts of saltmarshes.
RANGE All coasts.
FLOWERING TIME July–September.

This is the plant with the smaller, darker pink flowers in the illustration. The other plant, with the larger flowers, is greater sea-spurrey (*S. media*). Both species have low trailing stems with long, narrow and rather fleshy, yellowish-green leaves. They often grow together, making it easy to distinguish them on flower size alone. If a single plant is found, look at the petals; in *S. media* they are shorter than the sepals whereas in *S. marina* they are longer (or perhaps equal).

FAMILY Caryophyllaceae.
LENGTH To 40 cm.
HABITAT In the drier parts of saltmarshes.
RANGE All coasts.
FLOWERING TIME June–September.

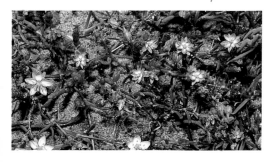

Common Sea-lavender

SALT MARSHES

190 *Limonium vulgare*

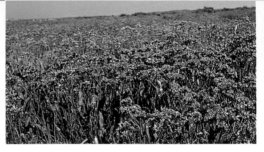

There are few more spectacular sights than a drab saltmarsh transformed into a sea of pink when this plant is in flower in its thousands. The branching stems arise from a rosette of broadly lanceolate leaves on long stalks. The tiny, pinkish-purple flowers are packed together in many-branched, somewhat flat-topped heads, borne on leafless stems. The relationship with true lavender (*Lavendula*) is in flower colour only.

FAMILY Plumbaginaceae.
HEIGHT 15–60 cm.
HABITAT In muddy saltmarshes.
RANGE All coasts but much commoner in the east; not northern Scotland.
FLOWERING TIME July–September.

This is often the commonest scurvy-grass in saltmarshes, although
in some it may be outnumbered by common scurvy-grass. The
leaves are longer and narrower than in the latter species and the
lowermost part of each basal leaf narrows gradually into its stalk,
unlike the rather heart-shaped leaf of the common species.

FAMILY Brassicaceae.
HEIGHT 20–40 cm.
HABITAT The wetter parts
of muddy saltmarshes.
RANGE Scattered on most coasts.
FLOWERING TIME April–May.

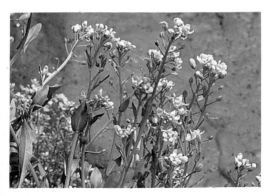

Sea-milkwort

Glaux maritima

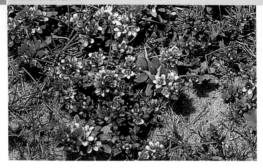

A coastal plant which is not related to the blue-flowered true milkworts. It is a straggling, prostrate plant, hairless and rather shining, with small, fleshy, more or less oval leaves arranged alternately up the thin stems. The small, pink flowers have no petals and arise from the bases of the leaves.

FAMILY Primulaceae.
HEIGHT 5–25 cm.
HABITAT Mainly along the edges of saltmarshes.
RANGE All coasts.
FLOWERING TIME June–July.

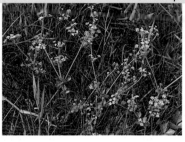

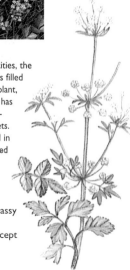

When this plant occurs in large quantities, the rather muddy smell of the saltmarsh is filled with the tangy aroma of celery. This plant, the ancestor of our cultivated celery, has tall, slim stems and hairless, yellowish-green leaves with large, toothed leaflets. The small, white flowers are arranged in slightly convex umbels and are followed by very small, globular fruits.

FAMILY Apiaceae.
HEIGHT 0.3–1 m.
HABITAT In saltmarshes and in grassy ditches nearby.
RANGE Scattered on all coasts except northern Scotland.
FLOWERING TIME June–August.

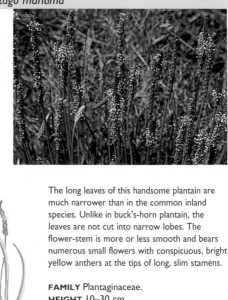

The long leaves of this handsome plantain are much narrower than in the common inland species. Unlike in buck's-horn plantain, the leaves are not cut into narrow lobes. The flower-stem is more or less smooth and bears numerous small flowers with conspicuous, bright yellow anthers at the tips of long, slim stamens.

FAMILY Plantaginaceae.
HEIGHT 10–30 cm.
HABITAT Saltmarshes, cliffs and other places on the coast.
RANGE All coasts and occasionally inland on mountains.
FLOWERING TIME June–August.

This wild relative of the familiar garden Michaelmas daisy varies greatly in its appearance. This is because the beautiful pinkish-mauve ray-florets so prominent in the illustration are often reduced to just a few, or even to none at all. This tends to be tied to locality, so that in some areas the plants almost never have any ray-florets, while in others they are almost always present.

FAMILY Asteraceae.
HEIGHT 20–100 cm.
HABITAT Mainly in saltmarshes, more rarely on cliffs.
RANGE All coasts.
FLOWERING TIME
July–October.

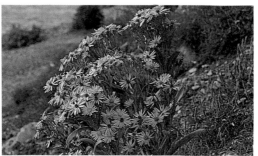

Triglochin maritimum

Despite its name, this is not a true grass, although the leaves and flowers are superficially grass-like. The narrow, hairless leaves are much fleshier than in any true grasses and form a dense, dark green tuft. The tiny, greenish flowers, on very short stalks, are crowded onto a long, slim, leafless spike.

FAMILY Juncaginaceae.
HEIGHT 15–60 cm.
HABITAT Saltmarshes and in salt-sprayed areas on dunes, etc.
RANGE All coasts.
FLOWERING TIME June–August.

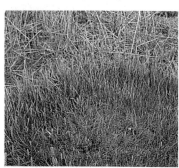

This is sometimes included in the genus *Bulboschoenus* which seems to be more appropriate as a sub-genus. The whole plant has a very rough feel to it, due to the coarse surfaces of the bright green, grass-like leaves and the sharp edges of the 3-angled stems. The dark brown flower-spikelets occur in a cluster and are shaped like rather slim eggs. Jutting up above these are several long, slender, leaf-like bracts.

FAMILY Cyperaceae.
HEIGHT 30–100 cm.
HABITAT Saltmarshes, mainly along rivers.
RANGE Common on all coasts.
FLOWERING TIME July–August.

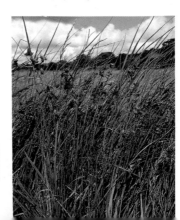

Cord-grasses

Spartina spp

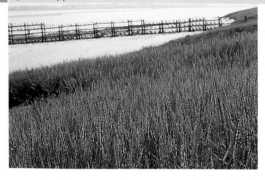

This is a very complicated group. The native small cord-grass, *S. maritium* is now often supplanted by the larger common cord-grass, *S. anglica*, which arose naturally as a result of an accident of hybridisation of the introduced smooth cord-grass (*S. alternifolia*) and the native small cord-grass. Small cord-grass is now local and common cord-grass is now by far the most abundant *Spartina*, often forming dense swards beside tidal rivers, excluding the native species. Distinguishing them is very difficult.

FAMILY Poaceae.
HEIGHT 50–80 cm.
HABITAT Tidal mud-flats.
RANGE Coasts, north to central Scotland.
FLOWERING TIME July–October.

Illustrated here is the form found on mudflats, formerly known as *P. purbeckensis*. Like most *Pardosa* species it is a rather hairy, brown spider that lives on the ground. It is only reliably separated from several similar species by examination of the genitalia with a lens. When the tide comes in, the spiders can survive long periods of immersion, their bodies covered in a bubble of air.

FAMILY Lycosidae.
LENGTH of body 4.5–9 mm.
HABITAT Saltmarshes.
RANGE All coasts.
SEASON All summer.
SIMILAR SPECIES The shingle wolf-spider (*P. agricola*) is very similar but lives on shingle.

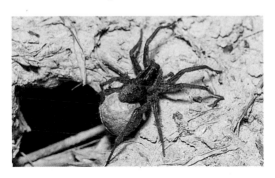

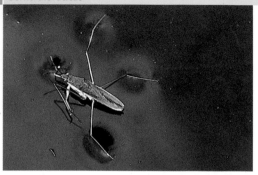

This is the only one of our six species of pondskaters that is common on brackish water. It is longer than our two really common species and the sides of its body are more or less parallel. There is no small brown patch on the sides of the pronotum (just behind the eye). The centre of the pronotum is yellowish or reddish, not black.

FAMILY Gerridae.
LENGTH 10–12 mm.
HABITAT Ponds and ditches, usually those with rather dirty water, both inland and on the coast. Often abundant on brackish ponds.
RANGE Widespread on all coasts.
SEASON All summer.

Short-winged Cone-head

In recent years this insect has expanded its range in Britain. It is often abundant in dense herbage on the edges of saltmarshes. Its basic colour is green, with a brown stripe down the back. The hind wings are reduced to mere vestiges, the forewings to small stumps. The female's ovipositor is quite long and curves upwards.

FAMILY Tettigoniidae.
LENGTH 11–17 mm.
HABITAT Moist places, among rushes etc.
RANGE Mainly southern coasts, northward to Yorkshire; not in Ireland.
SEASON Adult July–October.
SIMILAR SPECIES The long-winged cone-head (*C. discolor*) is fully winged.

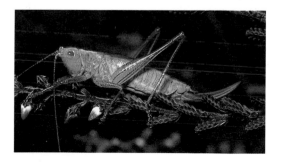

This handsome insect is easy to distinguish by the pale whitish band that runs around the margins of the side-flaps of the pronotum (above the front pair of legs). The underside of the abdomen is bright yellow, the hind wings are virtually absent and the forewings are stump-like. The basic coloration is brown mixed with green and yellow.

FAMILY Tettigoniidae.
LENGTH 13–17 mm.
HABITAT Mainly among the lush grasses and rushes of estuaries.
RANGE Mainly eastern coasts, northward to Yorkshire.
SEASON Adult July–October.

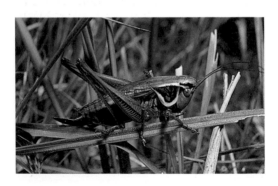

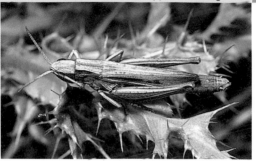

To distinguish this medium-sized grasshopper from the commoner
species, inspect the top of the pronotum (behind the head). Note
that the side-keels of the pronotum are roughly parallel, not bent
or curved inwards. Also, the forewings do not usually project back
beyond the hind knees. The main body can be either green or pale
brown.

FAMILY Acrididae.
LENGTH 13–21 mm.
HABITAT Usually in damp coastal grassland and sometimes
on dunes.
RANGE South and east coasts, north to Lancs. and Yorks.;
rare in Wales and Ireland.
SEASON Adult July–September.
SIMILAR SPECIES Common field grasshopper (*C. brunneus*).

Cliffs and Clifftops

In late spring there are few more colourful scenes than a clifftop garlanded with a spectacular array of pink thrift, white sea campion and yellow kidney vetch. On many western coasts these are, perhaps surprisingly, accompanied by carpets of bluebells. The short grass sward on an uncultivated clifftop is a mixture of plants that thrive best in salt-laden winds and those that can survive, but do not require, such conditions. The underlying rocks largely dictate the distribution of the non-specialists. On acid rock, coastal heathland will often develop, while on limestone, plants such as orchids are very much at home. The seaside specialists such as thrift do well on all types of soil – they just need the sea nearby.

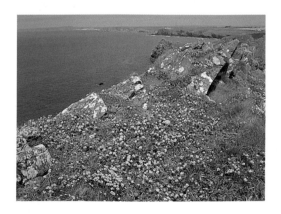

This is a dainty fern forms tufts in crevices in sea cliffs, both in full sun and in shade. The bright green, rather shiny leaves are noticeably tough and leathery and are well able to withstand the salty spray that often drenches them during winter storms. The stalk is brown, the midrib green and the spore-capsules beneath the oblong leaflets are arranged in elongated heaps on the side veins.

FAMILY Aspleniaceae.
LENGTH To 40 cm but usually much shorter.
HABITAT On cliffs, walls and buildings.
RANGE All coasts except for Hampshire eastward to south-east Yorks.
SIMILAR SPECIES The very common maidenhair spleenwort (*A. trichomanes*).

Sea Beet

Beta vulgaris ssp maritima

Sea beet is a rather untidy-looking plant and is the
ancestor of our cultivated beets and spinach. The shiny,
hairless leaves are, as with so many seaside plants,
noticeably thick and leathery. The lower leaves are
more or less triangular in shape, with wavy edges,
but those on the upper parts of the tall stems
are narrow and elongated. The tiny, wind-
pollinated flowers are green.

FAMILY Chenopodiaceae.
HEIGHT 30–70 cm, usually sprawling.
HABITAT Grows anywhere near the sea.
RANGE All coasts except for most of north
and central Scotland.
FLOWERING TIME June–September.

An attractive, small, prostrate perennial with a woody base, from which arises a branching stem, furnished with tufts of narrow, dark green leaves. The whole plant is glandular and has an unpleasantly sticky feel. The vivid pink flowers are larger and brighter than in related coastal species and may form a miniature carpet of colour on clifftop rocks.

FAMILY Caryophyllaceae.
LENGTH To 35 cm.
HABITAT On clifftops, rocks and walls.
RANGE Coasts of Ireland, Wales, south-west Scotland and western England.
FLOWERING TIME June–September.
SIMILAR SPECIES See other spurreys.

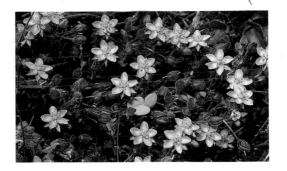

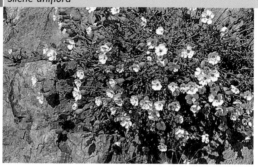

White drifts of this attractive plant are a characteristic feature of our clifftops. The greyish leaves are quite thick and waxy. The relatively large, white flowers are usually borne singly on each stem but form a striking mass when many buds are open simultaneously. The petals are broader than in the closely related bladder campion.

FAMILY Caryophyllaceae.
HEIGHT 15–20 cm.
HABITAT Mostly clifftops, also on shingle and rarely on mountains away from the sea.
RANGE All coasts.
FLOWERING TIME May–August.
SIMILAR SPECIES Bladder campion (*S. vulgaris*) found rarely on clifftops.

This very variable plant is often split into a number of 'microspecies' but here it is treated as a single variable species. The variation falls within an overall theme that makes this plant unmistakable. It is the only plant of clifftops that has dense heads of small, pinkish-purple flowers set on winged stalks, atop a tuft of fairly narrow, dull green leaves. Other sea-lavenders are plants of saltmarshes.

FAMILY Plumbaginaceae.
HEIGHT 10–15 cm.
HABITAT Mostly on cliffs.
RANGE Quite common in SW England and parts of Wales, rare elsewhere.
FLOWERING TIME July–September.
SIMILAR SPECIES See common sea-lavender.

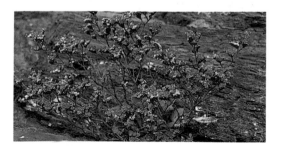

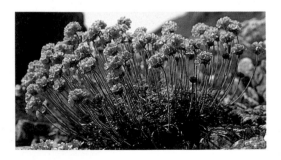

When in massed flower in late spring this is the most spectacular of our clifftop plants. The pom-poms of pink flowers are held aloft on slender, rather downy stalks. These arise from dense cushions of very narrow, pointed, grass-like and rather fleshy, bright green leaves. The flowers vary from almost white through to deep bright pink and occur over a very long season.

FAMILY Plumbaginaceae.

HEIGHT 5–25 cm.

HABITAT Commonest on cliffs, also in saltmarshes and very rarely on mountains far inland.

RANGE Common on all coasts.

FLOWERING TIME April–September.

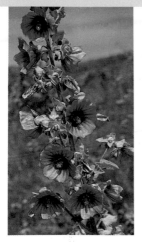

A tall perennial with a woody trunk and pink flowers which is not like any other seaside plant. The large, dull green leaves are wonderfully soft to the touch and have a rather crinkled appearance. The deep pinkish-purple flowers reach 5 cm across and usually have four deep green spots arranged in a square around the dark centre.

FAMILY Malvaceae.
HEIGHT Up to 2.5 m.
HABITAT Clifftops, walls, banks and roadsides near the sea.
RANGE Common in Cornwall, becoming rarer to the north. Rare and probably not native east of Dorset; scattered in Ireland.
FLOWERING TIME July–September.

Cochlearia officinalis

When it occurs in pure white drifts the flowers of common scurvygrass fill the air with their sweet perfume but are individually only tiny. They are borne on crowded heads on quite floppy stems, above a mass of bright green, soft, fleshy leaves which are either kidney- or heart-shaped. The spherical seed-pods are very prominent en masse.

FAMILY Brassicaceae.
HEIGHT 10–25 cm.
HABITAT Clifftops and saltmarshes; increasing by salted roadsides inland and also found on mountaintops.
RANGE Common on all coasts.
FLOWERING TIME April–August.
SIMILAR SPECIES See other scurvygrasses.

A much smaller, daintier plant than common scurvy-grass (with
which it often grows), with a more sprawling style of growth. The
prostrate stems bear stalked leaves, the uppermost usually being
ivy-shaped, the lowermost heart-shaped. The small
flowers are often pale lilac and are succeeded by
egg-shaped seed-pods.

FAMILY Brassicaceae.
HEIGHT 5–10 cm.
HABITAT Commonest on cliffs but
also on shingle, sand and in other
seaside habitats.
RANGE All coasts.
FLOWERING TIME February–September.
SIMILAR SPECIES Other scurvy grasses.

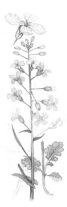

This handsome plant is the ancestor of the Brussels-sprout, cauliflower and broccoli. The bluish-green, hairless, quite fleshy leaves arise from a stout, woody stem that on older plants is marred by the scars of shed leaves. The unopened buds always project well above the pale yellow open flowers.

FAMILY Brassicaceae.
HEIGHT 30–70 cm.
HABITAT Only on sea cliffs.
RANGE Scattered around southern coasts.
FLOWERING TIME May–August.
SIMILAR SPECIES Sea radish (see under shingle). Black mustard (*B. nigra*), also common on cliffs, is easily distinguished by its bristly lower leaves.

Brookweed

Samolus valerandi

A dainty, rather slender perennial which is characteristic of wet flushes on cliffs but is also found in damp meadows, ditches, dune slacks and the edges of saltmarshes. The slender, usually unbranched stems arise from a basal rosette of oval, bright green leaves. The small, white flowers are borne on long stalks, giving a superficial resemblance to scurvygrasses.

FAMILY Primulaceae.
HEIGHT 5–15 cm.
HABITAT Damp sites near the sea, also inland in disused gravel workings.
RANGE All coasts except north-east Scotland; scattered inland.
FLOWERING TIME June –August.

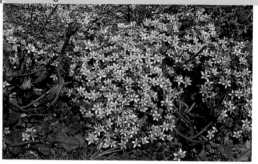

By far the commonest of the 'white' stonecrops, the flowers of this species are often tinged with pink which, along with the frequent rosy colour of the leaves, gives the whole plant a strong reddish flush. The small, stubby leaves are fat and succulent and the star-like flowers sit upon very short stalks.

FAMILY Crassulaceae.
HEIGHT 2–5 cm.
HABITAT Cliffs, walls, also dunes and shingle.
RANGE All coasts but much commoner in the west, rare and scattered in the east.
FLOWERING TIME June–August.
SIMILAR SPECIES White stonecrop (*S. album*) is much taller and usually found as an escape on walls near gardens.

The broad, yellow, silky mats of kidney vetch are a characteristic
sight on dunes and clifftop grasslands. The red-flowered variety
illustrated (var. *coccinea*) is restricted to the grassy tops of sea cliffs
in Cornwall and Pembrokeshire. In Cornwall white, pink, red,
orange or yellow flowered forms can all be found together in some
areas.

FAMILY Fabaceae.
HEIGHT 5–30 cm.
HABITAT Cliffs, walls, dunes.
RANGE All coasts.
FLOWERING TIME May–August.
SIMILAR SPECIES Common bird's-
foot trefoil (*Lotus corniculatus*) is not
silky and has much shorter, broader leaves.

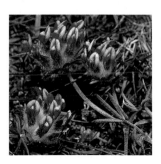

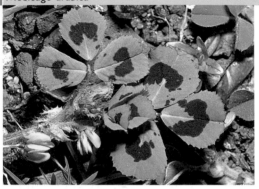

The dark-spotted leaves of this sprawling plant often form a dense underfelt in clifftop grasslands, among which the small, pale yellow flowers are quite inconspicuous. However, the leaves can also be unspotted, although they are always more or less hairless. The strange coiled fruits are sharply spiny.

FAMILY Fabaceae.
HEIGHT 2–6 cm.
HABITAT Clifftop grasslands and other grassy places.
RANGE Only common on south coasts.
FLOWERING TIME April–August.
SIMILAR SPECIES Toothed medick (*M. polymorpha*) is much rarer, weakly hairy and never with blotched leaves.

One of our drabber clovers but
very characteristic of most
coasts. The leaflets are downy
on both surfaces and the clusters
of tiny, white flowers are borne
on small, unstalked heads. These
are quite widely spaced out along
the generally creeping stems.

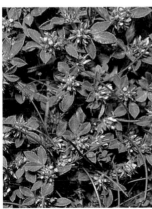

FAMILY Fabaceae.
HEIGHT 3–10 cm.
HABITAT Clifftops
and in short grass on
dunes; also in short
turf and bare open
spots inland.
RANGE Most coasts
but in Ireland only
around the south-
east; scattered inland.
FLOWERING TIME
May–June.
SIMILAR SPECIES Soft
clover (*T. striatum*) is
very similar but has
pink flowers.

Smyrnium olusatrum

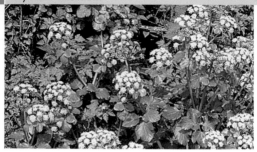

One of the few 'umbellifers' that is easy to identify on sight. The dark green, bushy plants often grow in massed ranks along roadsides near the sea and smell a bit like celery. The solid stems bear large, dark green, very glossy leaves divided and then again subdivided into threes. The dull yellow flowers occur in a domed umbel and are followed by conspicuous, black, globular fruits.

FAMILY Apiaceae.
HEIGHT 0.6–1.2 m.
HABITAT Roadsides, hedgebanks and waste places near the sea.
RANGE Not native but now widespread on most coasts north to central Scotland.
FLOWERING TIME April–June.

This is one of the most distinctive members of the parsley family, whose numerous white-flowered members can be so confusing. It is the only 'umbellifer' with thick, fleshy, dull greyish-green leaves cut into numerous narrow leaflets, giving the rather squat plants a densely bushy appearance. The pale cream flowers occur in rather open, flat-topped or slightly convex umbels.

FAMILY Apiaceae.
HEIGHT 30–45 cm.
HABITAT Within the spray zone on sea cliffs; very occasionally on sand or shingle.
RANGE Common along western coasts; only as far north as Suffolk on the east coast.
FLOWERING TIME July–September.

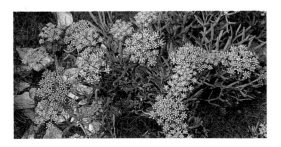

Fennel

Foeniculum vulgare

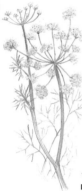

The tall, feathery plants of this introduced species smell strongly of aniseed. Originally grown as a kitchen herb it has managed to establish itself in many places near the sea and on roadsides and waste ground inland. The feathery leaves with their hair-like segments are unmistakable, while the yellow flowers occur in large umbels.

FAMILY Apiaceae.
HEIGHT Up to 2.5 m.
HABITAT Open places near the sea, cliffs, walls, dunes, quaysides, rarely far from houses.
RANGE All coasts but not in Scotland and the far north of England; scattered inland.
FLOWERING TIME July–September.

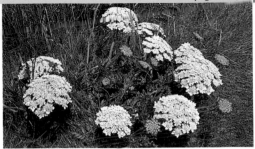

The only white umbellifer that occurs in large masses on sea cliffs. The very stout and rather squat, solid stems are topped by very broad, convex umbels of pure white flowers, all except for the central flower, which is deep red. As the fruits mature, the umbel contracts and becomes strongly concave.

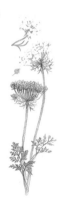

FAMILY Apiaceae.
HEIGHT 15–30 cm.
HABITAT Clifftops and dunes.
RANGE Along the west coast, from Anglesey to Kent, and round southern Ireland.
FLOWERING TIME June–August.
SIMILAR SPECIES Hogweed (*Heracleum sphondylium*) can be as common on cliffs but is much larger.

Plantago coronopus

On heavily grazed or trodden clifftops the entire plant of this common species may be only 3 cm across and 1 cm high. In more sheltered spots the rosettes of rather downy, pale green leaves can be 20 cm across. The flower spikes are always shorter than in other similar plantains, with very pale cream pollen.

FAMILY Plantaginaceae.

HEIGHT 4–6 cm.

HABITAT In bare places near the sea, mainly in short clifftop swards, also on rocks and on the edges of saltmarshes.

RANGE All coasts.

FLOWERING TIME May–June.

SIMILAR SPECIES See sea plantain.

Sheep's-bit

The bright blue, pom-pom heads of this spectacular
plant often form dense drifts on acid clifftops in the
west, especially in Cornwall and Pembrokeshire. The
thread-like stems and very narrow leaves are unlike
any related plants, while the tiny, blue flowers are crowded
tightly into a head 0.5–3.5 cm across. In exposed sites the
plants can be tiny, with only one or two flower-heads.

FAMILY Campanulaceae.
HEIGHT 3–50 cm.
HABITAT On acid soils, common on clifftops.
RANGE Mainly along western coasts.
FLOWERING TIME May–September.
SIMILAR SPECIES Some species of scabious
are vaguely similar.

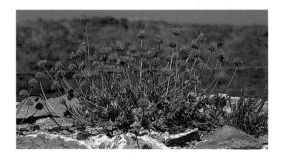

Carduus tenuiflorus

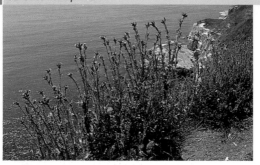

The thistles can be a confusing group but this is one of the easier ones to identify. The slender stems are noticeably winged and the flower-heads are much narrower than in any other thistle and of a much paler, almost washed-out pink. The whole plant is rather downy and has a whitish-grey appearance and the undersides of the leaves are white and cottony.

FAMILY Asteraceae.

HEIGHT 60–80 cm.

HABITAT Roadsides, waste places and clifftops by the sea; casual inland.

RANGE All coasts except northern and western Scotland.

FLOWERING TIME June–August.

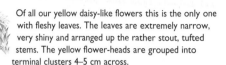

Of all our yellow daisy-like flowers this is the only one with fleshy leaves. The leaves are extremely narrow, very shiny and arranged up the rather stout, tufted stems. The yellow flower-heads are grouped into terminal clusters 4–5 cm across.

FAMILY Asteraceae.

HEIGHT 30–90 cm.

HABITAT The spray zone of sea cliffs, more rarely in saltmarshes and on shingle.

RANGE On most coasts but not north of Suffolk on the east coast and in Ireland only in the south and east.

SIMILAR SPECIES Common fleabane (*Pulicaria dysenterica*) has yellow flowers and is common in damp places on cliffs.

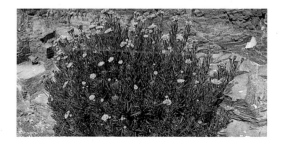

In sheltered places the stems are often
half sprawling but on exposed cliff they
are shorter and stouter and remain upright.
The very bushy leaves consist of numerous
narrow, almost hair-like segments. The
flower-heads are quite large, reaching 3 cm
or more across, with a yellow centre
bordered by white ray-florets, like large daisies.

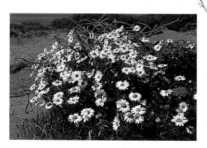

FAMILY Asteraceae.
HEIGHT 15–40 cm.
HABITAT Commonest on clifftops.
RANGE All coasts.
FLOWERING TIME June–September.
SIMILAR SPECIES A dwarf stout-stemmed form of the
oxeye daisy (*Leucanthemum vulgare*) is common on cliffs.

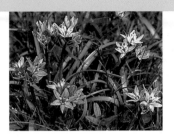

A carpet of tiny, blue flowers of this charming little plant often turns large expanses of clifftop sward blue in the more western parts of our islands. When not in flower, even massed ranks consisting of thousands of plants can be missed because the short leaves are very grass-like.

FAMILY Liliaceae.
HEIGHT 3–15 cm.
HABITAT Restricted to short-grass clifftops.
RANGE All coasts, except Dorset to Cheviot in the east; Ireland, on the east coast only.
FLOWERING TIME April–June.
SIMILAR SPECIES Autumn squill (*S. autumnalis*) is taller, slimmer, has more purplish flowers (July–September) and is much rarer.

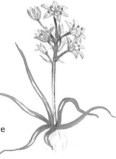

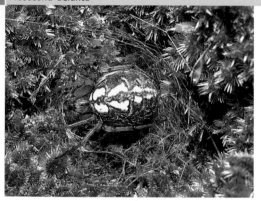

This spider's pattern is highly distinctive and cannot really be confused with that of any other spider. Although local, it can be abundant where it does occur. The adults often spend the day sitting on a plant beside the web, as in the female illustrated.

FAMILY Araneidae.
LENGTH Female 5–7 mm; male 4–5 mm.
HABITAT Rarely more than 200 m from the sea, on tall grass, gorse, sea carrot.
RANGE Quite common around the southern coasts, as far north as Wales and Yorkshire; also around southern Ireland.
SEASON Adult July–August.

Great Green Bush-cricket

Tettigonia viridissima

This large, robust insect is our biggest member of the order Orthoptera (grasshoppers, crickets etc). In the female a long, sword-like ovipositor projects out from the rear end. This can look quite intimidating but is harmless. The males sing loudly in daytime from dense cover.

FAMILY Tettigoniidae.
LENGTH Females 49mm (excluding ovipositor); males 45mm.
HABITAT Among rank vegetation, often in damp areas, on clifftops.
RANGE Mainly southern and coastal, rare inland. Common along the coasts of Dorset, Devon and Cornwall.
SEASON Adult late summer into the autumn.

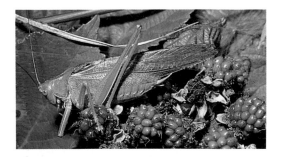

With its narrow, dark body and transparent wings this insect looks more like a slim-bodied wasp than a moth. Females are usually found flying from one thrift plant to another or walking around on the plants looking for a place to lay their eggs. Caterpillars live in the crowns and roots of thrift, reddish patches on the plant revealing their presence.

FAMILY Sesiidae
LENGTH 16–20 mm
HABITAT Rocks and cliffs by the sea where its thrift food plant is abundant.
RANGE West coasts of England, Wales and Scotland, scattered in Ireland.
SEASON Adults in June and July.

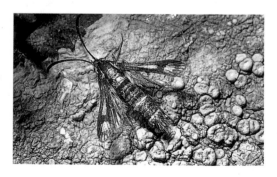

Slender-bodied Digger Wasp

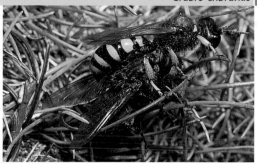

With its conspicuously broad head, this is one of the larger examples of the many species of solitary hunting wasps that nest along our coastline. The females nest in burrows in the ground on clifftops and in grassy banks. They catch large flies such as bluebottles (as illustrated) which are carried back to the nest in flight. The tibia (the fourth segment) of the male's front leg is distinctively spade-like.

FAMILY Sphecidae.
LENGTH 10–15 mm.
HABITAT Dry, grassy places.
RANGE Commonest along southern coasts, rare in Scotland and absent from Ireland.
SEASON June–September.
SIMILAR SPECIES See sand tailed digger.

There are few parts of the coast which will not present you with an interesting selection of bird life, though the species present will, in many instances, vary from one season to another. Most estuaries support populations of wading birds, as the mud is rich in the small animal life on which they depend, and during winter large flocks of ducks may be found on their relatively sheltered waters. Rocky coasts on the other hand, often with their extensive cliffs, tend to have a different set of birds. These usually nest on the cliffs during the summer, obtaining food for their young from the surrounding waters, while in the winter they may wander far out to sea, seldom coming to land.

Mudflats and cliffs are perhaps the most rewarding habitats for observing coastal birds but a good deal of care needs to be exercised here. The tide comes in very rapidly over the mudflats and it is easy to become trapped if you are not careful, especially if your feet become stuck in the mud. It is best, therefore, to observe the birds from dry ground rather than wander on to the mud. Cliffs are high and cliff edges may crumble, so also take great care here. Looking across an inlet from one set of cliffs to the opposite ones is usually the safest policy.

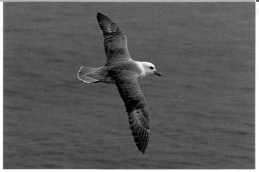

One of the great joys of a coast walk is to stand on a clifftop
watching the stubby-bodied, long-winged fulmars as they glide
effortlessly above the sea. Though superficially resembling gulls,
they are in fact small relations of the albatrosses and petrels and a
closer examination will reveal the tube nose above the beak
characteristic of this family of birds.

LENGTH 47 cm.
HABITAT Cliffs.
DISTRIBUTION All around the coast
where steep, high cliffs are present.
SEASON All year but at sea during
the winter.
SIMILAR SPECIES Some of the smaller gulls.

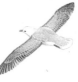

One of our largest seabirds, with their dagger-like bill and long, slim wings with black tips they cannot be mistaken for any other coastal species. They are at their most exciting to watch if they happen to find a shoal of fish close inshore. On spotting a suitable fish, they fold their wings into a W-shape and dive headfirst into the sea after it.

LENGTH 90 cm.
HABITAT Nests on high cliffs and stacks, otherwise at sea.
DISTRIBUTION Mainly north and west coasts, east coast as far down as Yorkshire.
SEASON Breeds April–September.

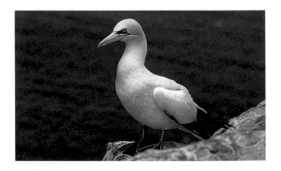

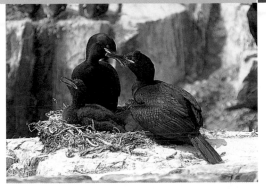

The shag is an almost exclusively coastal bird, unlike its larger
cousin the cormorant, which is often found on inland waters. In
summer the shag's feathers are basically black with an overall green
sheen and, characteristically, those on top of the head can be raised
as a crest. They tend to form nesting groups on cliffs and rocks in
the breeding season.

LENGTH 76 cm.
HABITAT Cliffs and stacks or out at sea.
DISTRIBUTION Mainly north and west coasts.
SEASON Breeds March–September.
SIMILAR SPECIES Cormorant, which
has a white throat when mature.

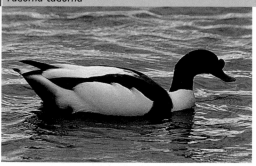

With its relatively long legs and neck the shelduck has the appearance of a small goose, though close examination reveals that it is indeed a duck. From a distance it is a black and white duck with a red bill and chestnut-coloured belt around the 'shoulders', though the black head is in fact a shiny dark green. Males have a red knob at the top of the beak.

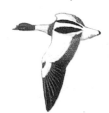

LENGTH 60 cm.
HABITAT Mainly estuaries but also sandy shores.
DISTRIBUTION All coasts.
SEASON Occurs all year, breeds from May onwards.

One of our largest ducks, the drake eider is white above and black below, with a black mask over the eyes, while the female is overall brown with a pattern of heavy black bars. Eider are easily recognised in flight, for they have a unique pattern of short bouts of active wing beats alternating with bouts of gliding.

LENGTH 58 cm.
HABITAT Rocky coasts.
DISTRIBUTION May appear anywhere in winter months, otherwise northern.
SEASON Breeds April–June in northern England and Scotland.

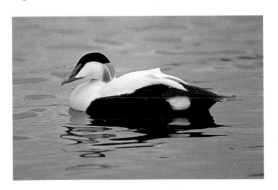

Haematopus ostralegus

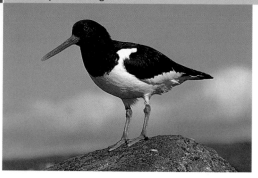

With its black and white plumage, long, red bill and red legs the oystercatcher is immediately identifiable. Although occasionally seen on their own, they occur most often in groups, when they can be very noisy, seeming to be bickering all the time with one another in their unmistakable piping calls. When the tide is in they can often be seen in fields bordering the coast.

LENGTH 43 cm.
HABITAT All types of coast.
DISTRIBUTION All coasts.
SEASON All year round, breeds April–August.

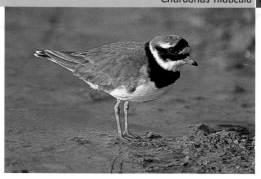

The ringed plover is a pretty little black and white bird, with a stubby, black-tipped orange bill. The wing feathers and those on the top of the head are a brownish-grey, so that the bird appears to be wearing a matching hat and cape. Like many small waders, it runs in short dashes, stopping every now and again to pick up a choice morsel of food.

LENGTH 19 cm.
HABITAT Sandy and shingle shores.
DISTRIBUTION All coasts.
SEASON All year, breeds April–July.
SIMILAR SPECIES Little ringed plover, has a black bill, summer visitor to all but south-east England.

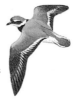

Tringa totanus

The redshank is a medium-size wader, recognisable by its red legs and long, reddish, black-tipped bill, while in flight its white back and rump are diagnostic. It is quite a noisy bird, especially when alarmed, when it may also bob up and down in a very characteristic manner. It is likely to be found looking for worms, shrimps, etc. on almost any shoreline.

LENGTH 28 cm.
HABITAT All types of shore.
DISTRIBUTION All coasts.
SEASON All year, breeds April–July.

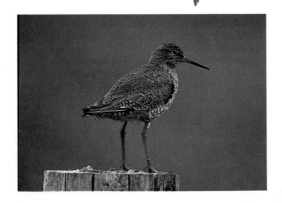

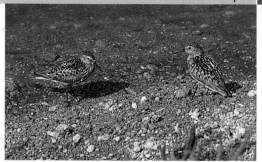

The commonest of our wading birds, which outside the breeding season may form flocks containing many hundreds of individuals. It has a short, dark beak which curves down slightly at the tip and during the summer its main distinguishing feature is the patch of very dark feathers on its lower breast.

LENGTH 18 cm.
HABITAT All types of shore and estuaries.
DISTRIBUTION Breeds in northern and western regions, all coasts at other times, or non-breeders.
SEASON All year, breeds May–August.
SIMILAR SPECIES Winter plumage similar to the larger knot.

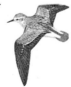

Perhaps the most familiar of our gulls, since it does not restrict itself to the coast but forages far inland during the winter months. It is our only grey gull with a bright red spot on the bill, at which the chicks aim to induce the adults to feed them. Herring gulls can be quite aggressive, especially near their nests.

LENGTH 56 cm.
HABITAT All types of shore.
DISTRIBUTION All coasts.
SEASON All year, breeds April–August.
SIMILAR SPECIES Common gull has green legs and is smaller and more delicate.

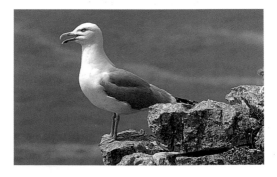

Lesser Black-backed Gull

Larus fuscus

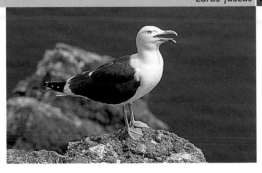

Very similar in size and build to the herring gull, and also with a red spot on the bill, but the lesser black-backed has black flight feathers on the wings. They may often be seen in mixed groups but the lesser black-backed tend to be somewhat more timid than the herring gull, keeping their distance from human observers.

LENGTH 53 cm.
HABITAT All types of shore.
DISTRIBUTION All coasts but mainly winter in the east.
SEASON All year, breeds May–August.
SIMILAR SPECIES Greater black-backed gull is larger and has flesh-coloured, not yellow, legs.

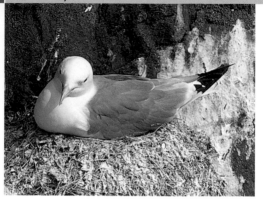

A pretty little gull which will only be seen perched
on or flying around cliffs or floating on the sea. It
is most easily recognised by its black legs, yellow
bill without a red spot and the pure black tips to the
wings when in flight (the similar common gull has a
white spot in its black wing tips).

LENGTH 40 cm.
HABITAT Breeding cliffs and at sea.
DISTRIBUTION All coasts, especially those with high cliffs.
SEASON All year, breeds May–August.
SIMILAR SPECIES Common gull, which has green legs.

Common Tern

Terns are sometimes referred to as 'sea swallows' on account of
their slim shape and long, forked tail. The common tern has this
typical form and is recognised by it black cap and orange bill with a
black tip. Beware of approaching too close to breeding colonies of
this and the Arctic tern for they are quite prepared to attack the
top of one's head with their sharp bills.

LENGTH 36 cm.
HABITAT Shingle beaches and at sea.
DISTRIBUTION All coasts.
SEASON A summer visitor,
breeds April–July.
SIMILAR SPECIES The Arctic tern has a red
beak with little or no black tip.

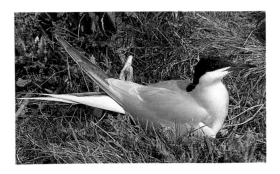

Sterna sandvicensis

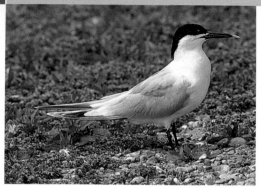

This is the largest of our terns approaching the kittiwake in size but with a more streamlined outline. Like the previous species it has a black cap, which it can raise like a crest, and a black beak with a yellow tip. It is most likely to be seen fishing off the beach, quite close in at times, hovering briefly before plunging into the shoals of small fish on which it feeds.

LENGTH 40 cm.
HABITAT Sandy or shingle
beaches or at sea.
DISTRIBUTION More likely to be seen
in the northern half of our area.
SEASON Summer visitor, breeds April–August.

Probably the commonest of the auks from around our coast. Like all of the auks, it flies with a very rapid wingbeat on its short wings. The bill is long and pointed and during the summer months the entire upper half of the bird, including the head, is dark brown while the underside is white.

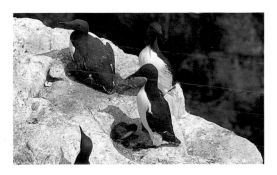

LENGTH 42 cm.
HABITAT Cliffs and stacks and at sea.
DISTRIBUTION All coasts where there are suitable cliffs, uncommon in the south-east.
SEASON All year, breeds May–July.
SIMILAR SPECIES The razorbill is darker and has a broader bill with white stripes, the black guillemot is all black with a white wing patch.

The smallest of our common auks, the puffin is easily identified by
its huge, multicoloured beak, which makes it look rather clownish
in appearance and gives it its alternative common name of 'sea
parrot'. It has an extremely rapid flight and may often appear to
have a large 'moustache' as it comes in from fishing with a beak full
of sand-eels.

LENGTH 30 cm.
HABITAT Cliffs, stacks and islands
and at sea.
DISTRIBUTION All coasts where there are
suitable cliffs, uncommon in the south-east.
SEASON Coastal only during the breeding
season, April–August.

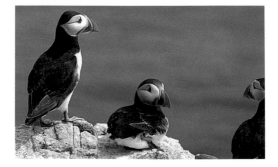

Rock Pipit

Anthus spinoletta

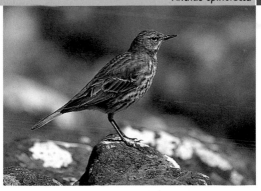

If along a rocky coast you see a bird which looks like a small, dark version of a song thrush, then it is almost certainly a rock pipit. They seem to be one of our tamer birds and can be approached within a few feet, without showing undue alarm, as they scuttle among the rocks seeking out small insects and similar prey as food.

LENGTH 16 cm.
HABITAT Rocky coasts.
DISTRIBUTION All coasts except
the south-east of England.
SEASON All year, breeds April–July.
SIMILAR SPECIES Not on the coast.

Jackdaw

Corvus monedula

The jackdaw, which is the smallest of the black members of the crow family, is just as much at home along our rocky coastlines as it is inland on old buildings, cliffs and hollow trees inland. It is smaller and lighter built than the rook and crow and has an obvious black cap on the head and a grey nape of the neck.

LENGTH 33 cm.
HABITAT Cliffs.
DISTRIBUTION All coasts.
SEASON All year, breeds May–June.
SIMILAR SPECIES None on the coast, except perhaps the raven which is twice its size.

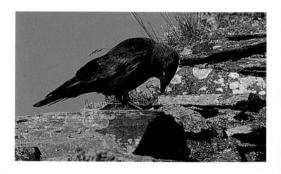

Glossary

anthers The male parts of flowers which produce pollen.

bivalve A marine or freshwater mollusc with a laterally compressed body and a shell consisting of two hinged valves.

bract A specialised leaf with a single flower or inflorescence growing in its axil.

calcareous Of, containing or resembling calcium carbonate.

carapace The tough, shell-like structure which covers the head and front part of the body of crabs and lobsters.

cephalothorax The front part of many crustaceans and some other arthropods consisting of a united head and thorax.

epiphyte A plant which grows upon another plant.

halophytes Plants capable of surviving in salty soils.

holdfast The branching base of the stem of a seaweed with which it holds onto rocks etc.

isopod A member of the crustaceans, with bodies flattened from top to bottom, to which the familiar woodlice belong.

lanceolate Of leaves; narrow, tapering to a point at each end.

molluscs Any of various invertebrates having a soft, unsegmented body and often a shell.

oscula Small openings in the body of a sponge through which water passes as it feeds.

ovipositor The tube on the end of the body through which female insects lay their eggs.

parasitise To live in or on another organism, feeding from it.

proboscis The tubular mouthparts through which insects suck food such as nectar and blood.

pronotum A tough, protective shield which covers the back of the thorax in some insects.

spore A reproductive body produced by many plants, which develops into a new individual.

stamen The male reproductive organ of a flower.

stolon A branching structure of lower animals, often the anchoring, root-like part of colonial organisms.

thorax The part of an insect's body between the head and abdomen.

umbel A cluster of flowers arising from the same point in the main stem with stalks of equal length, and with the youngest flowers at the centre.

umbellifer a herbaceous plant or shrub, typically having hollow stems and flowers in umbels.